# Rethinking
# HOW ART
# IS TAUGHT

*For Dale Reid, who teaches art and collects elephants*

# Rethinking
# HOW ART IS TAUGHT

## A Critical Convergence

## Donovan R. Walling

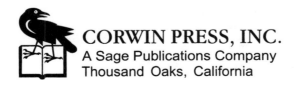

**CORWIN PRESS, INC.**
A Sage Publications Company
Thousand Oaks, California

*For information:*

Corwin Press, Inc.
A Sage Publications Company
2455 Teller Road
Thousand Oaks, California 91320
E-mail: order@corwinpress.com

Sage Publications Ltd.
6 Bonhill Street
London EC2A 4PU
United Kingdom

Sage Publications India Pvt. Ltd.
M-32 Market
Greater Kailash I
New Delhi 110048 India

Printed in the United States of America

*Library of Congress Cataloging-in-Publication Data*

Walling, Donovan R., 1948-
    Rethinking how art is taught : A critical convergence / by
Donovan R. Walling.
        p. cm.
Includes bibliographical references (p.     ) and index.
    ISBN 0-7619-7518-7 (cloth: acid-free paper)
    ISBN 0-7619-7519-5 (pbk.: acid-free paper)
    1.  Art—Study and teaching.  I. Title.
    N85 .W35 2000
    707'.1—dc21                                              99-006629

00   01   02   03   04   05   06   8   7   6   5   4   3   2   1

| Production Editor: | Denise Santoyo |
| Editorial Assistant: | Victoria Cheng |
| Designer/Typesetter: | Danielle Dillahunt |
| Indexer: | Kay Dusheck |
| Cover Designer: | Michelle Lee |

# Contents

# Acknowledgments

Many thanks to the following reviewers for their contributions to making *Rethinking How Art Is Taught: A Critical Convergence* a better book:

Nancy Senn
Program Manager
Family Museum of Arts and Science
Bettendorf, IA

Dr. Patricia Barbanell
President Elect, NYS Council of Educational Associations
Immediate Past President, NYS Art Teachers Association
Albany, NY

Suzanne Stiegelbauer
Associate Professor
Ontario Institute for Studies in Education of the University of Toronto
Toronto, Ontario Canada

Rebecca Ireland
Art Department Coordinator and Art Teacher
Indian River Central School District
Philadelphia, NY

Dr. Roxanna Albury
Lander University
Fine Arts Division
Greenwood, SC

# About the Author

Donovan R. Walling has directed the principal book publishing division of Phi Delta Kappa International, the professional fraternity for men and women in education, with international offices in Bloomington, Indiana, since 1993. Prior to joining the PDK staff, he served as director of instructional services for the Carmel Clay Schools in Carmel, Indiana.

From the start of his education career in 1970 until his move to Indiana in 1991, Walling was associated with the Sheboygan Area School District. He began his career teaching art and English at Farnsworth Junior High School (now Farnsworth Middle School). After leaving Farnsworth for a 2-year "tour of duty" as a teacher of art, English, and journalism in the Department of Defense Dependents Schools in Germany from 1981 until 1983, he returned to Sheboygan and taught at North High School until 1986. At that time, he moved to the position of coordinator of language arts and reading in the district's central administration, where he supervised all language-related curricula, including foreign language and English-as-a-second-language/bilingual programs.

Walling also has directed programs in gifted education in a variety of settings, and from 1987 to 1991, he was on the faculty of Silver Lake College in Manitowoc, Wisconsin, where he taught graduate courses on a part-time basis in the teaching of writing and whole language instruction.

Walling's numerous professional publications include books, monographs, and more than two dozen journal articles on topics such as

gifted education, the arts, language arts curriculum, school public relations, and staff development. His early books are *Complete Book of School Public Relations* (1982) and *How to Build Staff Involvement in School Management* (1984). His most recent books for the Phi Delta Kappa Educational Foundation are edited collections of essays, including Teachers as Leaders (1994); *At the Threshold of the Millennium* (1995); *Open Lives, Safe Schools* (1996); *Hot Buttons* (1997); and *Under Construction: The Role of the Arts and Humanities in Postmodern Schooling* (1997).

Walling also has written poetry and drama. His one-act radio dramas, *The Three-Chime Clock* (1979) and *Last Dance* (1988), won competitive awards and were produced by Wisconsin Public Radio. His stage play, *Writer's Catch,* was given its premiere performance in 1996 in the Sheboygan schools, where Walling began his career. In addition to writing, Walling also continues to paint and is active in community arts programs.

Walling grew up in a military family, attending 14 schools during his elementary and secondary education. He graduated from high school at Fort Sam Houston in San Antonio, Texas, where he met his late wife, Diana L. Eveland. Walling holds a bachelor's degree in education from the Kansas State Teachers College (now Emporia State University) and a master's degree in curriculum and instruction from the University of Wisconsin-Milwaukee, where he also did advanced studies in urban education. He is the father of three: a daughter, Katherine, in the St. Louis, Missouri, area; a son, Donovan, in Wisconsin; and an elementary school-age son, Alexander, at home.

# Introduction: Thinking About Art Education

There lingers the noble notion that art should be taught for its own sake, that the creative impulse of the true Artist should arise from no nobler source than a desire simply to make Art. Students should be drawn to art as Hillary was drawn to Everest, because it is there. At the risk of offending some readers from the very start, I will state that this is elitist nonsense. In fact, it is just this stance that, at least in part, has led art education to the periphery of the school curriculum, from which precarious edge it is now struggling to return to its rightful place—at the heart of schooling.

Anyone who has been involved in art education for long knows the reasoning that says, if the only purpose of art is art itself, then when budgets are tight we can do without. By this reasoning, once flourishing art education programs have been reduced to "art on a cart" or eliminated entirely. And it was just such reasoning that got art left out of the original national goals. Art was seen as an add-on—an elitist preserve for the artistically talented or, conversely, a holding room for those misfit kids who could not handle the regular curriculum—certainly not a "basic," not something for every student.

In fact, art always has served purposes beyond itself. I am not talking about craft art per se, eating utensils, ceramic bowls, or such works, over which traditionalists debate the difference between arts and crafts.

What I refer to are purposes such as representation, decoration, intimidation, and exhortation. Michelangelo's Sistine Chapel ceiling is not art for its own sake. It tells a story; it exhorts the faithful to piety; for Christ's sake—literally—it decorates a ceiling that otherwise would be a blank expanse. That utility should be noble enough. But there is more. Artistic endeavors also serve social and cultural purposes. Cawelti and Goldberg (1997) comment,

> The arts are the embodiment of human imagination, the record of human achievement, and the process that distinguishes us as human beings. We form human communities and cultures by making art—through stories and songs, drama and dance, painting and sculpture, architecture and design. (p. 1)

Today, the notion is growing that the arts, writ large, rightfully belong at the center of education and, indeed, may hold the key to successful education reform. This notion is growing not because the public or school boards or administrators suddenly have discovered the so-called nobility of art but rather because education researchers and arts practitioners—teachers and artists—have begun to document the utilitarian, educational purposes of instruction in the arts.

Researchers now suggest, for example, that art instruction may improve reading scores; that classes in art history and art criticism may be responsible for producing measurable improvements in vocabulary, writing, and critical thinking skills; that drawing activities undertaken before writing may lead to the production of higher quality writing (Hamblen, 1993).

James Bailey (1998) further contends that visual arts instruction will be essential at the center of schooling in the future because modern technology is reuniting art and science. "Bits and pixels" computer technology—spatial, nonlinear, all the balls in the air at once—is presupposed in new mathematical applications that cannot be expressed in letters and digits, thereby ending the overwhelming influence of print. Bailey reasons that "the printing press drove a five-hundred-year wedge between science and art, pushing the latter to the brink of extinction in the curriculum" (p. 17). New technology is bringing art back to the core.

Not since the Italian Renaissance in the 14th century have those concerned with the visual arts found themselves at center stage in a major cultural transformation. Today, on the threshold of a new millennium, those who understand that the arts are essential in the human experience have an unparalleled opportunity to rethink art education and to

reshape how the visual arts are taught in schools. This is happening because of a critical convergence of ideas—hence the title of this book.

In the past 25 years, a global transformation has occurred—and it is occurring still—as a result of a critical convergence of ideas from many sources, many disciplines of study, many aspects of the human condition. This convergence includes new perspectives on existing knowledge, discoveries of new knowledge, and inventions that have emerged during a relatively short period. Separately these ideas are important; together they are creating the critical thought-mass necessary to radically change how humans view the world and their place in it. A critical convergence is the engine that shifts the paradigm. And the critical convergence of the late 20th century is empowering the arts in ways not seen since the Renaissance.

In discussing how art education theorists, teachers, and artists might think about art education in new ways, I address five topics. Each is the subject of a separate chapter. Chapter 1 looks at the new "official" interest in art education, beginning with the national goals that were formalized in the Goals 2000 legislation of 1994, Goals 2000: Educate America Act. That chapter takes up how the national goals arose; how political forces and the influence of educators shaped the goals; and how those goals connect to national arts standards, state standards and curricula, local standards, and classroom practices.

Chapter 2 takes up discipline-based art education theory, which was developed in the late 1970s and early 1980s. DBAE, as it is known, posits a multidisciplinary approach to art education, incorporating the teaching of aesthetics, art criticism, art history, and studio art. Employed as it was intended, DBAE can restore depth to the teaching of art and return art to the core curriculum.

Chapter 3 is an examination of postmodernism. The past quarter century has witnessed dramatic, paradigmatic shifts in the wake of the emerging Information Age. These shifts include the ascent of multiculturalism, globalism, and family diversity—all of which affect the teaching of art. The postmodern period is marked by pluralism and complexity, which are driving forces in reshaping school curricula.

Chapter 4 contrasts behaviorism and constructivism and explores educators' changing beliefs about knowledge, human abilities, and learning. Constructivist teaching offers a utilitarian perspective on how best to integrate the influences of postmodernism with the expanded notion of art education that is embodied in DBAE theory.

Chapter 5 goes to the heart of the Information Age to examine new computer technology for applications that can serve art education, such as computer-assisted art production and arts research using the

resources of the Internet. I also take up the use of so-called virtual field trips and their applications (and limitations) for classes and individuals.

Chapter 6 is designed to summarize the convergence of these five areas. I discuss how goals and standards, DBAE theory, postmodern themes, constructivist teaching, and Information Age technology can be integrated to rethink how art is taught. I also explore assessment issues and what still needs to be done in practice and application in individual classrooms as well as in the more general area of arts research.

To assist art educators charged with, or interested in, reshaping the teaching of art, I include in each chapter a section titled "Refining the Model." The purpose of this section is to develop—over the course of six, chapter-based steps—a template for applying the ideas expressed in the chapters.

Through the ages there have been points of convergence, times when myriad changes in human perspectives, discoveries, and inventions—in science, religion, government, technology—have coalesced to transform the prevailing worldview. Art has played a role in all of these shifts but not always a central or even a very important role.

For example, in the 18th century a number of forces came together to produce the Industrial Age, which was marked not merely by transformations in manufacturing—the "industry" element of the Industrial Age—but also by radical changes in other aspects of science and society. The visual arts played no particular role in that societal transformation, however, although they were affected by it. A transformation in art came later with the subsequent invention of photography, which freed artists from the obligations of representation in painting and printmaking. That Industrial Age invention, more than any other single factor, opened the door to the abstract movement and the modern period in the visual arts.

The Renaissance was an altogether different matter, however. The arts were at the center of that paradigm shift. One has merely to consider the range of ideas represented by the great names. Johannes Gutenberg (1400?-1468?) changed the very nature of learning and knowledge acquisition with the invention of movable type and the publication of the *Mazarin Bible* about 1455. Nicolaus Copernicus (1473-1543) confronted the prevailing worldview with his theory that the sun, not the earth, was the center of the universe. Martin Luther (1483-1546) rocked the religious world. And Leonardo da Vinci (1452-1519) challenged dominant notions not only in art but also in

science and engineering. The Renaissance was a critical convergence in which the arts were at the core, not on the periphery.

Not since the Renaissance have the arts been so positioned to play a pivotal role in the shaping of human destiny for a new century. My goal in this book is to explore the critical factors that are now at work in society and specifically in education and to suggest ways that those concerned about the future of art education can think about theory and practice as we stand on the threshold of a new century and a new millennium.

## REFERENCES

Bailey, J. (1998, Spring). The Leonardo loop: Science returns to art. *Technos,* pp. 17-22.

Cawelti, G., & Goldberg, M. (1997). *Priorities for arts education research.* Washington, DC: Goals 2000 Arts Education Partnership.

Goals 2000: Educate America Act, Pub. L. No. 103-227.

Hamblen, K. A. (1993). Theories and research that support art instruction for instrumental outcomes. *Theory Into Practice, 32,* 191-198.

# 1

## GOALS, STANDARDS, AND CURRICULUM REFORM

In the well-known poem about the six blind men of Indostan and the elephant,[1] each blind man describes a part of the elephant—its tail is like a rope, for example—without gaining a sense of the entire beast. Because I fear that some readers may feel about the chapters of this book the way the blind men felt when confronted by the elephant, I will take some pains before beginning to set out my plan. The chapters may seem unrelated at first glance, but readers who are willing to suspend their disbelief will discern the connections that I will make plain, in any event, by the end of the final chapter. I aim to paint an elephant that looks, when the last brush stroke has been applied, like an elephant.

My approach to the complex convergence of critical ideas that are (or, in my view, should be) shaping art education on the threshold of a new century and millennium is akin to developing a comprehensive curriculum. It is only natural for me to use such a schema because it draws on a career history of teaching and curriculum development. But I also believe it is a natural or, at least, an accustomed framework for most educators. That should make the going easier. Allow me to label the girders and joists of this framework.

In the Introduction, I wrote about the purposes of this book so that readers will have a sense of where I am headed. This chapter makes a subtle change of direction that is followed in the remaining chapters, which is to examine the topic of a critical convergence in art education from the standpoint of where art education is, could be, or should be headed. Following a basic curriculum planning model, then, I take up *goals and standards* in this first chapter. Chapter 2 follows with a *conceptual framework* for art education—another schema, if you will. And

Chapters 3, 4, and 5, respectively, develop *curriculum, instruction,* and what might be termed *enrichment* (technological extension and enhancement).

In this way each chapter offers up a part of the elephant for consideration. Now, even though I have said that I want my elephant to look like an elephant, all visual artists know that if one looks closely enough at any painting, any piece of a painting, it will become abstract. Some of these chapters present concepts that seem rather abstract as well. Two devices may help to render the abstract more concrete. One is the section in each chapter labeled "Refining the Model." These sections develop the "model" that I suggest will be useful in rethinking art education. The second device is simply Chapter 6, a summary chapter that I use as a way of stepping back from the canvas to see the entire elephant.

And so, with this plan firmly in mind, I take brush in hand and step to the easel.

## GETTING THE ARTS INTO THE NATIONAL GOALS

In *Pudd'nhead Wilson,* Mark Twain wrote, "One of the striking differences between a cat and a lie is that a cat has only nine lives." The national goals movement had its beginning in a great lie, *A Nation at Risk,* the 1983 National Commission on Excellence in Education report that distorted the true condition of the public schools in the United States and spawned the growth industry of school reform.

For example, *A Nation at Risk* pointed to the "low quality" of the public schools as threatening the nation's competitiveness in the world economy. But the U.S. economy has ranked number one in every year since that report was issued and is ranked by the World Economic Forum as the most competitive economy in the world. If economic competitiveness is a standard for comparison, then America's public schools must already be performing at the desired level.

That *A Nation at Risk* intentionally erred in its assessment of schools is no longer disputed by thinking educators. America's "rising tide of mediocrity" has been debunked by any number of researchers and analysts, such as David Berliner and Bruce Biddle in their 1995 book, *The Manufactured Crisis: Myths, Fraud, and the Attack on America's Public Schools,* and Gerald W. Bracey in a series of annual reports that have appeared in the *Phi Delta Kappan* since 1991. Bracey, in his very first *Kappan* report, noted, "The evidence overwhelmingly shows that *American schools have never achieved more than they currently achieve.* And some indicators show them performing better than ever" (Bracey, 1997, p. 6, italics in original).

Yet in the popular mind the lie has many lives, as evidenced by each new critical factoid splashed in negative headlines and articles that gloss questionable studies with shaky conclusions. But the truth is emerging, gradually but persistently. Blaming the schools for society's ills was the national pastime of the 1980s. In the 1990s the public has wearied and is increasingly suspicious of this ploy. Right-wing torch-bearers for the great lie are being forced to look for other sport. The continual attacks on America's public schools have been debilitating and demoralizing in many respects, but they are becoming less and less credible with the passage of time.

As vexatious as the onslaught against the public schools has been over the past two decades, even a great lie sometimes can be turned to advantage. The schools have become a focal point for a good deal of positive energy as well, and paying attention to what happens in schools is by no means bad. If that focus can be maintained and if educators can use the national attention to solve some of the real problems that schools face, then unfounded criticisms can be deflected and children may become, at last, real beneficiaries of reform and not merely commodities to be manipulated by self-serving pundits and politicians.

Where, one might ask, was art education in this mess? And where is it now?

At first the answer simply would have been, "Nowhere." The arts did not figure in the national goals until they were passed into law during the first Clinton administration. How they got there merits a brief recounting.

Art education in the 20th century often has found itself on a slippery slope leading to the outer edge of the school curriculum. Inadequate funds—or funds diverted to other purposes—frequently have been the grease. But modernist and postmodernist controversies—from cultural debates over High Art versus Low Art to disputes in Congress over National Endowment for the Arts funding of "immoral" art—also have served as excuses for school boards to shunt art education onto a siding, ejecting it from the core of schooling and frequently treating it as little more than a frill, like golf or cheerleading. School leaders of limited vision have seen art education as elitist, as they have similarly regarded gifted education; or, alternatively, art classes have been viewed as holding pens for students unable or unwilling to cope with the requirements of more "rigorous" subjects (in other words, the college-prep track). Both perceptions contribute to keeping art education outside the curriculum mainstream.

The curriculum reform movement that was set in motion by the National Commission on Excellence in Education (1983) report often

seems, even today, like a runaway train. But most art educators realize that however wild the ride, being on the train is essential if the arts are to be returned to the mainstream or (as many believe they should be) to be made elemental in the core curriculum—in other words, on a par with mathematics, science, and language. That is a far cry from where the arts began in the national goals.

It should be remembered that *A Nation at Risk* sparked intense interest in school reform, first at the state level. This is key because the states, not the federal government, control education. But federal initiatives can be powerful nonetheless, and state and federal collaborations can be particularly compelling. Two years after the report of the National Commission on Excellence in Education (1983) was published, the nation's governors took up education as the sole item on the National Governors' Association's 1985-1986 agenda. Tennessee governor Lamar Alexander, who later would become President George Bush's Secretary of Education, was the chairman that year; Bill Clinton, then governor of Arkansas, was the vice chairman. The reform train was chuffing out of the station.

"By the time of the 1988 presidential election," Alexander (1993) recalls, "almost every governor was describing himself or herself as an 'education governor.' . . . George Bush announced in the midst of his campaign that he intended to be the 'Education President'" (p. 10). Thus it came as no surprise that shortly after his election President Bush called for a bipartisan education summit. With extraordinary like-mindedness, the governors met in 1989 at the University of Virginia in Charlottesville under the joint leadership of Governor Clinton and Governor Carroll Campbell of South Carolina. With President Bush as an enthusiastic supporter, this summit came up with the first National Education Goals. There were six of them; the word *art* was nowhere to be seen.

In spite of its promising start, President Bush's national goals effort was derailed in Congress by members of his own party. John F. (Jack) Jennings (1995), then general counsel for education in the House of Representatives Committee on Education and Labor, recalls,

> President Bush complemented his meeting with the governors by sending to Congress legislation that he believed would reform education. That bill contained a number of small-scale programs seeking to change a few schools and practices. The Democratic House and Senate reluctantly passed a version of Bush's bill. However, very conservative Republican senators subsequently filibustered the final bill; and the initial Bush school reform initiative died in 1990. (pp. ix-x)

After Lamar Alexander was appointed in 1991 to serve as Bush's Secretary of Education, he moved the concept of national goals further by gaining the President's support for accompanying national standards. In creating the America 2000 initiative, Alexander, along with Chester Finn and other colleagues, took a cue from the work of Prime Minister Margaret Thatcher in Great Britain, who had pushed for the enactment of a national school curriculum for England and Wales. For President Bush this was a bold venture. Writes Jennings (1995),

> A Republican president proposing such national standards in education was the education policymaking equivalent to the reshaping of foreign policy when President Nixon went to China. Richard Nixon had made a career out of attacking Communism and calling liberals sympathizers of that ideology; and then he—not a liberal—opened the doors to "Red" China, the same doors that he had spent 25 years locking. (p. x)

But in spite of his boldness, President Bush did not succeed in getting a reluctant Congress to adopt America 2000.

The calendar pages flip to 1993. Bill Clinton, an enthusiastic supporter of the goals effort while he was governor of Arkansas, is now the President; and America 2000, renamed Goals 2000, has been "reengineered" by the Democrats under the leadership of the new Secretary of Education, Richard Riley. Much of the original concept remained unaltered, except for one small but significant addition: The word *arts* had been added to Goal 3:

> By the year 2000, all students will leave grades 4, 8, and 12 having demonstrated competency over challenging subject matter including English, mathematics, science, foreign languages, civics and government, economics, *arts*, history, and geography, and every school in America will ensure that all students learn to use their minds well, so they may be prepared for responsible citizenship, further learning, and productive employment in our Nation's modern economy. (italics added)

This one-word addition did not simply appear in Goal 3 as if by magic. It got there by dint of persistent lobbying by arts educators, artists, and arts thought-leaders at all levels. I will skip over that history because those debates are now less pertinent than the fact that the arts were included, and that inclusion was a necessary step. That inclusion got art education on the reform train. The actual pushing and tugging to get on board is no longer important, though I grant that those who did the pushing and tugging may not agree.

So . . . the arts were included in the National Education Goals. And the goals had been written into law as the Goals 2000: Educate America Act, which was signed by the President in March 1994. Now what?

## FROM NATIONAL GOALS
## TO NATIONAL STANDARDS

From a political standpoint the Goals 2000 legislation served two agendas, a national agenda and a state and local agenda. Secretary of Education Richard Riley (1995) calls the national goals "an important entry point to work with the states" and notes that President Clinton "strongly backed" the inclusion of the arts and foreign languages in Goal 3. Goals 2000 also served to solidify "a broad coalition of education, parent, and business groups" who joined the Congress and the President, the national PTA, and the National Education Association and the American Federation of Teachers, all of whom "threw their weight behind a goal focusing on better teaching and improved professional development" (p. 17).

Goals 2000 reiterated the importance of the National Education Goals Panel, the bipartisan group composed of governors, state legislators, members of Congress, the Secretary of Education, and others. And the legislation created a National Education Standards and Improvement Council (NESIC), designed to certify national standards that would be developed (or were already being developed), "voluntarily" by national professional associations or state and local groups.

Getting on the national reform train was a first step. Dwaine Greer (1997) comments that the inclusion of the arts in Goal 3 was announced to the art education world as a breakthrough:

> While the development of art standards might raise questions, it would not be productive to criticize the act of standard-setting itself. Rather, art educators and art education would be better served by adopting a "long transcending commitment" to making the arts a reality for all students. (p. 91)

Once art education boarded the reform train, the next big question was one of luggage: how much and what kind? These are the essential questions of any standards-setting effort. What sort of standards should be set? How specific should they be? Samuel Hope (1994), executive director of the National Association of Schools of Art and Design, rightly argues that the best course of action would reify the language of Goals

2000 by placing emphasis on what students should know and be able to do. The national art standards should not prescribe processes, methods, or resources. They should be generic goals rather than lists of specifics or, even less desirable, a national curriculum.

Hope and others argued well, and the consortium that produced the national arts standards heeded this wisdom. Since "arts"—plural—was the term used in Goal 3, it followed that *National Standards for Arts Education: What Every Young American Should Know and Be Able to Do in the Arts*, published in late 1994 by the Consortium of National Arts Associations, would be the product of many heads. The consortium included representatives from the American Alliance for Theatre and Education, the National Art Education Association, the Music Educators National Conference, and the National Dance Association. (A summary is available online at gopher://gopher.ed.gov/00/publications/full_text/arts/arts8) The consortium's work was funded by a grant from the U.S. Department of Education, the National Endowment for the Arts, and the National Endowment for the Humanities. And the standards developed by the consortium were endorsed by nearly a hundred other arts and education organizations.

The arts standards include standards for education in dance, music, theater, and the visual arts. Each field includes from six to nine content standards, and each standard is articulated across sets of grades: K-4, 5-8, and 9-12. The following statements summarize the five general standards for the visual arts:

1. The student understands and applies media, techniques, and processes related to the visual arts.
2. The student knows how to use the structures (for example, sensory qualities, organizational principles, expressive features) and functions of art.
3. The student knows a range of subject matter, symbols, and potential ideas in the visual arts.
4. The student understands the visual arts in relation to history and cultures.
5. The student understands the characteristics and merits of his or her own artwork and the artwork of others.

One standard is common to all of the arts disciplines: The student understands connections among the various art forms and other disciplines.

The framers of these standards resisted well the temptation to prescribe beyond general principles. "Media, techniques, and processes

related to the visual arts," for example, can be construed in almost any manner and thus can embrace the innovative as readily as the traditional. Curriculum makers at various levels can tailor the standards' "range of subject matter, symbols, and potential ideas" to match cultural, community, and individual needs and interests.

These standards also offer access to the various disciplines of art. For example, Standard 1 clearly relates to art production. Standards 2, 3, and 5 relate to aesthetics and overlap considerably with art criticism (particularly Standard 5). Art history is evident in Standard 4. (I discuss the relation of national arts standards to art disciplines in detail in Chapter 2.)

These national art education standards *are* very general, but they are nonetheless powerful. Ensuring, for example, that a student "understands the visual arts in relation to history and cultures," however more narrowly specified in a local curriculum, is likely still to present classroom teachers with a challenge. That challenge in the best situations can help to invigorate teaching and to awaken students' interests through a more rigorous curriculum.

The national reform train reached the states with relatively little real baggage but with both implicit and explicit legislative hopes. The state and local agenda of Goals 2000 was built on the legislation's intent of encouragement. Comments Riley (1995),

> Every state is encouraged to develop challenging *content* standards of its own choosing (what students are supposed to know) combined with *performance* standards (how well students must know the material). With the help of broad-based panels at the state and local levels, action plans will be developed to help students achieve these goals and standards, *as defined by each state and each community.* (pp. 17-18, italics in original)

## LOCALIZING THE NATIONAL STANDARDS

No sooner had Goals 2000 been passed than some critics pronounced the standards movement dead. This conclusion was reached by some analysts, in part, on the basis of problems with the National Education Standards and Improvement Council (NESIC).

NESIC had been created as part of the legislation and was charged with overseeing the development of voluntary standards by various national groups. But about 6 months after President Clinton signed the Goals 2000 legislation, Congress changed hands. The Republicans took control, and the new legislators, according to David Cohen (1995), "were generally more conservative and had little use for any sort of

national school reform. They had especially little use for an agency that would devise, promulgate and certify national education standards" (p. 752).

The toothlessness of NESIC was compounded in the states, where forces were gathering to stop the standards movement at that level. Marzano and Kendall (1996) comment,

> Campaigns have been mounted to stop identification of state standards in Virginia, Colorado, Oregon, Pennsylvania, and Washington, to name a few. Studies by the American Federation of Teachers (AFT) have concluded that state standards are, for the most part, weak. (p. 10)

I mention these two problem areas simply to put them on record. But such problems are not insurmountable and, perhaps, matter rather little in terms of localizing the national standards. After all, the national standards, once set, are beacons not easily extinguished. If the states are in a muddle, their messing about may buy time for local schools and districts to make the standards their own. That is where reforms and standards can have a direct effect. I agree with Marzano and Kendall (1996) when they write,

> In spite of a plethora of problems at the national and state levels, we do not believe that the standards movement is dead. In fact, we assert that the logic behind organizing schooling around standards is so compelling that schools and districts will implement standards-based school reform even in the absence of federal or state mandates or incentives. Indications are that the standards movement, though "fallen from grace" at the national level, is rising through reform efforts at the local level. (p. 11)

Thus the standards reform train comes huffing into the station, and it is up to the local porters to unload the baggage and see what the train has brought. That baggage is like bolts of cloth arriving in a frontier town. The tailors and seamstresses—local teachers, school administrators, parents, students, and other members of the community—must now use the standards to fit up their schools in new instructional clothing. But I will drop this metaphor rather quickly. It is too easy to leap mentally to the story of the emperor's new clothes, and that is not the most useful image.

With the national standards as a foundation, it becomes a local task to erect a curriculum; to establish a framework for that curriculum; and to activate that curriculum through instruction, which also may be enriched or extended either globally or particularly. (Computer technology, for

example, might allow for "global" enrichment that is available to all or most school systems. A nearby museum, on the other hand, might serve as a source of enrichment for only a particular school system or a small group of systems.)

In these activities I part company, philosophically, with Marzano and Kendall (1996), who see the generic character of the national arts standards as a potential problem. For example, they compare the national arts standard, "understanding the arts in relation to history and cultures," with the national history standard, "students should understand the causes of the Civil War." They continue by saying that the history example is "obviously more specific" than the arts example and that "the history document provides more detailed information for each of its standards than does the arts document" (p. 22). Then they conclude,

> The degree to which standards are articulated in specific terms is critical because the level of specificity adopted by a school or district will affect the level of detail within the standards, the degree of comprehensiveness the standards aim for, and the number of standards created. (pp. 22-23)

I do not disagree with this point in itself. Rather, I disagree that greater detail at the national level is necessarily better than less detail *at that level*. A more general standards statement at the national level, in fact, was what the arts standards writers sought. That is the virtue toward which the framers of the arts standards aimed, precisely *not* to tie the hands of local standards makers with overspecific national standards. What Marzano and Kendall see as problematic, local arts educators—if Hope (1994), cited previously, and others are correct—should see as advantageous because it allows them to match local standards more closely to local needs.

I will not debate here whether knowledge of the Civil War is important or not. I will posit that singling out the Civil War presumes a traditional—national—canon in which certain knowledge is sacrosanct. The arts standard in Marzano and Kendall's (1996) example makes a more modest assumption, one less bound by canonical prejudice, and so allows local educators greater freedom to localize the standard.

## LOCAL STANDARDS–LOCAL CURRICULUM

That last small paragraph opens a very large Pandora's box. What, after all, *should* the art curriculum include? What specifics should be hung onto the framework of the standards? Several philosophical starting

points come to mind, but two are perhaps most pertinent to mention at this stage.

The first is recent thinking that posits a global, multicultural, nontraditional orientation for school curricula in general. Those voicing such a "postmodern" philosophy—and I will take up postmodernism in greater detail in Chapter 3—harken to ideas expressed previously by curriculum theorists loosely labeled "reconceptualists." This is the *content* philosophy question for local standards makers.

The second is the additional work done by the Consortium of National Arts Education Associations in specifying second-tier standards by grade-level groupings in its 1994 standards document. This is the *process* philosophy question, which I take up in the next section of this chapter.

Let me say more about the content question. Arthur Costa and Rosemarie Liebman (1995) discuss two reasons for departing from traditional disciplines in general, but their reasoning is sound in relation specifically to how art education standards at the local level also must be conceived:

> First, the disciplines, as we have known them, no longer exist. They are being replaced by human inquiry that draws upon generalized, transdisciplinary bodies of knowledge and relationships. . . .
>
> Second, curriculum, based on discrete disciplines, emerged from a largely male- and western-oriented way of thinking. As we learn to listen to the female voice, gain greater understanding of the perspectives of indigenous peoples, and become more global, our curriculum will need to reflect richer views of how humans construct meaning. (p. 23)

These concerns arise from a reconceptualist orientation stated some years ago by James B. Macdonald, one of the founding fathers, if you will, of reconceptualist theory. Macdonald (1977) wrote that the reconceptualists (and their successors) are those who "tend to bracket curriculum talk by the human condition—who probably would agree . . . that curriculum praxis is a reasonable microcosm of the macroscopic world, and thus curriculum talk is bounded only by its concrete referents within the human condition" (p. 13).

I call on this history merely to point out that what Costa, Liebman, and others are saying today is not new. But their tone of urgency surely comes, in part, from the knowledge that others have voiced this viewpoint in the past. And it is time to move forward in implementing this content philosophy. Macdonald, William Pinar, Herbert Kliebard, and others were publishing reconceptualist views during the 1970s and early 1980s,

which, not coincidentally, jibes with the advent of postmodernism and the development of discipline-based art education theory.[2]

One has to ask, referring to Macdonald's (1977) comment, what is the human condition? Or perhaps, as some will ask, what *should* the human condition be? These abstract questions are grounded in the concrete reality that the content of the curriculum is not without bounds. A curriculum can contain only so much information, so much content. The question—What content is most worth knowing?—is pertinent. It is on this point that the reconceptualists and their successors part company with the traditionalists and the traditional canon. The question for art educators, therefore, is this: How do we achieve balance between the two extremes of these philosophical positions, given the age in which we live? (My own bias may be noted in that last phrase, "given the age in which we live.")

Todd Gitlin (1998) pinpoints this challenge to local standards writers and curriculum developers when he comments that "while the liberal arts seek to cultivate knowledge, reason, aptitude, and taste for what endures, we live in a society devoted to relentless cultural change" (p. B4). Although Gitlin argues more strongly for a canonical grounding, his regard for tradition—for things that "endure"—is set on ground that art educators must tread in arriving at local standards. "The strongest reason to cultivate knowledge that is relatively enduring," says Gitlin, "is to anchor a reckless, lightweight culture whose main value is marketability" (p. B5). He goes on:

> Common concerns about life and death, right and wrong, beauty and ugliness persist throughout the vicissitudes of individual life, throughout our American restlessness, global instabilities, the multiple livelihoods that we must shape in an age of retraining, downsizing, and resizing. We badly need continuities to counteract vertigo as we shift identities, careen through careers and cultural changes. . . . Today's common curriculum would not be that of 1950—anymore than 1950's was that of 1900. What overlap it would have with the past would generate cultural ballast. (p. B5)

Gitlin's plea is reasonable. "Surely," he concludes, "the academic left and right (and center) might find some common ground." Indeed, that is one of the major challenges for local educators, parents, students, and others concerned about art education in their schools.

In the chapters that follow, I offer additional ways of viewing this content challenge. But, for the moment, let me move on to the process question.

## STANDARDS THAT
## GUIDE LOCAL EFFORTS

The Consortium of National Arts Education Associations (1994) provided not only the general standards that I noted previously but also second-tier standards for grade-level groupings. Take the interdisciplinary standard, for example: *The student understands connections among the various art forms and other disciplines.* For students in kindergarten through Grade 4, this general standard also means that the student

- Knows how visual, aural, oral, and kinetic elements are used in various art forms
- Knows how ideas (such as sibling rivalry, respect) and emotions (such as sadness, anger) are expressed in various forms
- Knows the similarities and differences in the meanings of common terms used in the various arts (such as form, line, contrast)
- Knows ways in which the principles and subject matter of other disciplines taught in the school are interrelated with those of the arts (for example, pattern in the arts and in science)

Now, some readers will argue that these are not process standards at all. Rather they are very general content standards. They are, after all, labeled "content standards." But at the risk of being accused of begging the question, I will argue that they are so vague, so general, as to constitute only an indication of direction, which I feel more comfortable in characterizing as a process leading toward specific content. Ultimately, I readily admit, dichotomizing content and process serves little purpose. The specific content will be determined at the local level. And at the local level the process also will be refined.

Let us examine a second-tier standard: *Knows the similarities and differences in the meanings of common terms used in the various arts (such as form, line, contrast).* Several standards-setting tasks devolve to the local level, which may be considered in the form of questions:

- How should this standard be set for students at each level within the grade-level span? What does it mean for kindergartners, for first graders, and so on?
- What are the "common terms"? Which should be taken up at each grade? Is a "spiral curriculum" concept valid?

- What level of knowledge sophistication will be expected? To use Bloom's taxonomy, is "knowing" defined by simple application, by analysis of similarities and differences, by evaluating how the similarities and differences affect a work of art?
- What exemplars will teachers use to illustrate the meanings of the common terms? From which cultures will they be drawn? What aesthetic considerations should be taken into account?
- Can students construct knowledge of similarities and differences by making art—that is, by active production rather than passive study of form, line, contrast, and so on?

Readers will surmise, correctly, that this list is merely a starting point. My interest at this stage is in suggesting how the standards-setting process might be approached, not to prescribe what local educators should set as standards.

## REFINING THE MODEL

I appreciate Douglas E. Harris and Judy F. Carr's (1996) comment: "The development of standards-based curriculum is not a linear process" (p. 12). They also remind their readers that a commitment to rethinking curriculum need not begin with the scrapping of all existing work. Like thoughtful artists, thoughtful educators view curriculum as work in progress, reshaping the form here, erasing and redrawing a line there.

In developing a "model," if you will, for thinking about art education, I will suggest three essential questions or areas for reflection:

1. What are the "universals" that must be included in art education?
2. What are the local (school, community) considerations, such as culture, norms, and expectations, that must be included in art education?
3. What "space" in art education must be defined in which students can address individual needs, interests, and abilities?

The shorthand references that I use in future "Refining the Model" sections for these three areas are: *universals, the community,* and *the individual.*

The first step in building a model for thinking about art education is to frame responses to these questions as they apply to the art standards. For

example, a few paragraphs earlier I suggested that one question about the K-4 second-tier standard was, What exemplars will teachers use to illustrate the meanings of the common terms? In responding to this question art educators need to be able to define the "universals"—in other words, what exemplars might most teachers use, regardless of locale. What is the canon? This question is not intended merely to call up the so-called traditional canon that Costa and Liebmann (1995) say is "largely male- and western-oriented." Rather, it is intended to raise debate about the content of an art canon for America at this time in its history.

Next, standards makers need to define the exemplars pertinent to the local community. All communities possess art and localized understandings about art. (Those localized understandings also will shape the debate over the art canon.) There are exemplars in the architecture and the public art of the community; in the community's museums, galleries, and shops; in the work of local artists; and in the influences that come from nearby communities. All of these elements affect the community's art norms, expectations, and resources.

Finally, the question about individual "space" must be addressed. How will individual students be encouraged or empowered to construct meaning based on their own pursuit of art knowledge? Maxine Greene (1974), writing with other reconceptualists in the 1970s, captured this point when she suggested that "the person brought to self-awareness . . . is far more likely to feel a desire for orientation or a desire to constitute a range of meanings than one who is confronted in isolation with independently existing knowledge structures" (p. 82). Attention to individual student needs, interests, and abilities is essential to developing standards in which students will invest themselves, not merely their time.

Universals, the community, and the individual will be the anchor points in future "Refining the Model" sections. They are essentials against which all other considerations must be cross-referenced if educators are to rethink art education for the next century.

# NOTES

1. "The Blind Men and the Elephant," by John Godfrey Saxe (1816-1887).

2. I recognize that the term *discipline-based* seems to contradict Costa and Liebman's (1995) notion that the disciplines no longer exist, but I will argue that matter in Chapter 2.

## REFERENCES

Alexander, L. (1993). What we were doing when we were interrupted. In John F. Jennings (Ed.), *National issues in education: The past is prologue*. Bloomington, IN: Phi Delta Kappa International and the Institute for Educational Leadership.

Bracey, G. W. (1997). *The truth about America's schools: The Bracey reports, 1991-97*. Bloomington, IN: Phi Delta Kappa Educational Foundation.

Cohen, D. (1995). What standards for national standards? *Phi Delta Kappan, 76* (June), 751-757.

Consortium of National Arts Education Associations. (1994). *National standards for arts education: What every young American should know and be able to do in the arts*. Reston, VA: Music Educators National Conference.

Costa, A., & Liebman, R. (1995, March). Process is as important as content. *Educational Leadership*, pp. 23-24.

Gitlin, T. (1998, May 1). The liberal arts in an age of info-glut. *Chronicle of Higher Education*, pp. B4-B5.

Goals 2000: Educate America Act, Pub. L. No. 103-227.

Greene, M. (1974). Cognition, consciousness, and curriculum. In W. Pinar (Ed.), *Heightened consciousness, cultural revolution, and curriculum theory*. Berkeley, CA: McCutchan.

Greer, W. D. (1997). *Art as a basic: The reformation in art education*. Bloomington, IN: Phi Delta Kappa Educational Foundation.

Harris, D. E., & Carr, J. F. (1996). *How to use standards in the classroom*. Alexandria, VA: Association for Supervision and Curriculum Development.

Hope, S. (1994, March). The standards challenge: A communication from Samuel Hope. *Art Education*, pp. 9-13.

Jennings, J. F. (Ed.). (1995). *National issues in education: Goals 2000 and school-to-work*. Bloomington, IN: Phi Delta Kappa International and the Institute for Educational Leadership.

Marzano, R. J., & Kendall, J. S. (1996). *A comprehensive guide to designing standards-based districts, schools, and classrooms*. Aurora, CO: Mid-Continent Regional Educational Laboratory (McREL). Copublished with the Association for Supervision and Curriculum Development (ASCD).

Macdonald, J. B. (1977). Values bases and issues for curriculum. In A. Molnar & J. A. Zahorik (Eds.), *Curriculum theory*. Washington, DC: Association for Supervision and Curriculum Development.

National Commission for Excellence in Education. (1983, April). *A nation at risk: The imperative for educational reform*. Washington, DC: Government Printing Office.

Riley, R. W. (1995). The Goals 2000: Educate America Act. Providing a world-class education for every child. In J. F. Jennings (Ed.), *National issues in education: Goals 2000 and school-to-work*. Bloomington, IN: Phi Delta Kappa International and the Institute for Educational Leadership.

# 2

# A Disciplines Approach to Comprehensive Art Education

The next part of this elephant that I have called a critical convergence is concerned with a conceptual framework for reform in visual arts education. The schema that is most useful is that of discipline-based art education theory, or DBAE.

In the Introduction, I suggested that art education has been pushed to the periphery of schooling, at least in part because airy notions about art for art's sake have allowed non-arts educators, school officials, policymakers, parents, and the general public to miss the real point of art education: Art education is, or should be, a basic part of education because art itself is an essential part of everyone's life. One remembers the Swiss painter Paul Klee's declaration (in his "Creative Credo," 1920): *"Kunst gibt nicht Sichbare weider, sondern macht sichbar."* ("Art does not reproduce what is visible, rather it makes things visible.")

Unfortunately (for all students), visual arts education was conceptually reduced over the first half of the 20th century to a primary purpose of assisting students with "creative self-expression"—a self-limiting vision if ever there was one. This notion held sway until the 1960s, when the post-Sputnik education reform wave began to wash ashore some new notions about the nature of schooling. Jerome Bruner (1960), in particular, must be credited with giving voice to the idea that students should learn not just the facts about school subjects but also should gain "an understanding of the fundamental structure of whatever subject we choose to teach" (p. 11). Some arts educators—for example, Manuel Barkin at Ohio State University—picked up Bruner's idea and began to

look at how the content of art education might be broadened to encompass other art disciplines in addition to art making, which had become the primary, if not exclusive, focus of most school art.

But the seeds of a new conceptual framework for visual arts education did not sprout immediately. Writes Brent Wilson (1997),

> The social and educational climate of the 1960s and 1970s was not conducive to a rigorous disciplined approach to visual arts education.... Nevertheless, a small number of curriculum developers, researchers, evaluators, and theoreticians in art education continued to work with Bruner's and Barkan's ideas, and a few university art education programs prepared art teachers in comprehensive approaches to art education. (pp. 38-39)

A few words about the social and educational climate of the 1960s and 1970s may help to establish a perspective. In the 1960s—the post-Sputnik era—much of the early attention to schools focused exclusively on beefing up math and science instruction. Later the Johnson administration widened the focus, particularly with the enactment of the Elementary and Secondary Education Act (ESEA) in 1965, which brought a number of new social initiatives into the schools.

But any real gains for schools in the 1960s were diminished by the decade of the 1970s. The baby boom had crested, and schools seemingly overnight began to feel the pinch of declining enrollments. Most districts lost hundreds, large districts thousands, of students; buildings were closed, grades were reshuffled. The energy crisis of the decade exacerbated the situation. School renovations—motivated by shifting enrollments and energy conservation needs—further constrained already diminished arts programs. "Extra" spaces—from music practice rooms to art studios—were converted to other purposes. Auditoriums became cafeterias; theater arts programs died; arts staffs were reduced. Not until the early 1980s would the notion of a disciplines approach to art education gain any real ground. Then, given the declines of the previous decade, art educators would feel some urgency to move forward at last.

## DBAE: A BRIEF HISTORY

The phrase *discipline-based art education* was settled on in the 1980s through the efforts of the Getty Education Institute for the Arts, previously known as the Getty Center for Education in the Arts, a program of the late billionaire's J. Paul Getty Trust. Two recent books provide an

overview of DBAE history, undergirding theory, and practical applications. *The Quiet Evolution: Changing the Face of Arts Education* (Wilson, 1997) was written for the Getty Institute by Brent Wilson, a professor of art education and head of the art education program in the School of Visual Arts at Pennsylvania State University. From 1988 to 1996 Wilson headed the Getty Institute's evaluation team for professional development institutes for DBAE.

The other book is *Art as a Basic: The Reformation in Art Education* (1997) by W. Dwaine Greer, a professor of art at the University of Arizona in Tucson. Greer set out the initial definition of DBAE in an article titled "A Discipline-Based Art Education: Approaching Art as a Subject of Study," which was published in *Studies in Art Education* in 1984. That article was followed by a monograph, "Discipline-Based Art Education: Becoming Students of Art," written by Greer and two colleagues, Clark and Day, that was published, along with other articles commissioned by the Getty Institute about the antecedents of DBAE, in a special issue of the *Journal of Aesthetic Education* in 1987. Ralph A. Smith collected many of these early writings in *Discipline-Based Art Education: Origins, Meaning, and Development* (1989). Writes Greer (1997),

> During the period when this new focus on art as a content-centered subject was emerging, I was involved in a number of the conferences and projects that addressed the need to change art education practice. This work came to a turning point as I was asked to develop the Getty Institute for Educators on the Visual Arts and to set about defining the orientation to art education called discipline-based art education, more often known by its initials as DBAE. . . . This current understanding of art as a discipline is a synthesis of developments that have taken place since the 1960s. (p. 4)

"DBAE," writes Wilson (1997), "builds on the premise that art can be taught most effectively by integrating content from four basic disciplines—art making, art history, art criticism, and aesthetics (the philosophy of art)—into a holistic learning experience." In so doing, however, the framers of DBAE, working with the Getty Institute, were asking a great deal. Indeed, Wilson continues, "the Getty Education Institute envisioned a sweeping transformation in theory and practice that asked educators to alter traditional ideas, learn to regard art in unfamiliar ways, and introduce new art programs in their classrooms" (p. 10).

I am reminded of the truism stated in the "This We Believe" section of the National Art Education Association's *A Vision for Art Education*

*Reform* (1995): "The *way* art is taught is part of *what* is taught" (p. 1). DBAE offered, and continues to offer, a way to teach art using an integrated disciplines approach that not only changes what most art teachers teach but also promises to alter the public view of the nature and value of art education.

To accomplish this transformation, in 1987 the Getty Institute established a program of regional institute grants (RIGs) to support the development and operation of regional consortia that would set about doing the field work necessary for change. Fifty-two consortia applied, and a rigorous screening process was used to choose six that would receive matching grants (totaling some $3.5 million) as regional institutes. These consortia were charged to become national leaders and "to prepare a critical mass of school districts to implement DBAE districtwide over a five-year period" (Wilson, 1997, p. 13). Wilson continues,

> As research and development centers, the regional institutes were given the latitude to create innovative and effective professional development programs; provide technical assistance, instructional materials, experts, and other resources to schools; attract and mobilize school districts as partners and prepare them in DBAE; and forge strong links to their respective communities by finding local funding partners. (p. 13)

As an integral part of this initiative the Getty Institute provided for the 7-year evaluation (1988-1995) that is reported in Wilson's (1997) book, in which he characterizes the hoped-for transformation in art education as "quiet evolution." The most important achievement of the RIGs, notes Wilson, has been the transformation of DBAE theory into exemplary practice. Therefore, in the remaining pages of this chapter, I turn to that practice: to the basic tenets of DBAE and how the art disciplines can be integrated into a holistic framework from which to derive curriculum and instruction.

## INTEGRATED ART DISCIPLINES

Following Bruner's (1960) notion of giving students "an understanding of the fundamental structure" of art (p. 11), DBAE theorists posited that such an understanding could best be gained through an integrated disciplines approach. Four art disciplines were singled out: aesthetics, art criticism, art history, and art production (also referred to as art making or studio art). Greer (1997) expands the definition of DBAE in this way:

Discipline-based art education, as a part of general education, aims to de-
velop mature students who are comfortable and familiar with major as-
pects of the disciplines of art. The goal is amplified in this manner: Stu-
dents will be able to express ideas with art media; will read about and
criticize art; will be aware of art history as the chronological, geographic,
and personal context of what they are seeing all around them, not just in
galleries and museums; and will have an understanding of the basic issues
of aesthetics. (p. 4)

Greer also points out the importance of emphasizing that "this devel-
oped understanding and appreciation of art is sought for *all* students"
(p. 4)—hence the title of his book, *Art as a Basic*. A guiding aim of DBAE
is to place art education at the heart of schooling. Writes Greer,

The placement of art in the general curriculum changes the previous "elec-
tive" understanding of the place and value of art learning. It says, instead,
that the study of art is to be viewed in the same manner—and must carry
the same expectations—as other basic disciplines, which extend the tradi-
tional 3 R's. (p. 4)

But the road to the center of the curriculum from its periphery is a diffi-
cult one. In fact, it is a road taken by only a relatively small number of
school districts so far, but more are contemplating the journey as the va-
lidity of DBAE practice emerges.

Indeed, DBAE—because the theory seeks to place art education at
the heart of schooling—has had to "evolve" in ways that reflect both
curricular and political realities. But I reserve this point for later in this
chapter. First, it is important to understand the four component disci-
plines: aesthetics, art history, art criticism, and studio art.

## AESTHETICS

The discipline of aesthetics is culture bound. What is valued in art is de-
termined within a context of time and place. A simplistic notion of aes-
thetic value is conveyed in cultural decisions about what is "beautiful."
For example, in 19th-century France, the forms of Neoclassicism consti-
tuted the aesthetic value—what was considered beautiful—of that age
and place. The exemplars then were Antonio Canova (1757-1822),
whose Neoclassical sculpture prefigured many of the works of Jean-
Auguste-Dominique Ingres, the painter. Ingres (1780-1867) set the na-

tional aesthetic tone not only through his work but also as president of the Ecole des Beaux-Arts in 1850 and senator in 1862.

When the Impressionists set to work in earnest about midcentury, their art, in essence, declared war on the Neoclassical aesthetic. It would be remarked of Paul Cézanne (1839-1906), "The idea of beauty was not in Cézanne. He had only the idea of truth" (according to Emile Bernard, 1869-1941, who carried on a lively exchange of letters with Cézanne). But Cézanne's "truth" became the next aesthetic, the cultural value of Impressionism, as evidenced by the late 19th-century works of Cézanne himself, Edgar Degas (1834-1917), Claude Monet (1840-1926), Paul Gauguin (1848-1903), and many others. John Rewald (1985) writes that "despite different ideas and different approaches, different attitudes and different contributions, together they [the Impressionists] ran a self-promoting and apparently inexhaustible academicism to the ground" (p. 191). And so a new aesthetic was formulated that would dominate until the advent of modernism.

For a more recent foray into aesthetic debate one can turn to England and Prince Charles's now largely defunct campaign for traditional architecture. "The Prince," writes Paul Goldberger (1998), "declared war on modern architecture in 1984, in a speech in which he called a proposed addition to the National Gallery 'a monstrous carbuncle on the face of a much loved and elegant friend'" (p. 52). Prince Charles's expressions of outrage over modern architecture are informed by a personal aesthetic, not by any resort to formal criticism. Indeed, as Goldberger points out, the prince has no formal training in architecture: "Charles's architectural education, one of his friends has remarked, consisted of 'looking out the window of a Rolls-Royce listening to his mother and grandmother saying, "Isn't all that ugly?"'" (p. 54). But just as Ingres's aesthetic passed out of fashion, so, too, has the aesthetic of the prince been superseded by a newer vision. "If Britain's modernists weren't exactly in the mainstream in 1984," writes Goldberger, "they are unquestionably the establishment today" (p. 59).

## ART HISTORY

The foregoing description of aesthetics provides an example of why basic knowledge of art history is a useful discipline. Without some prior understanding of Neoclassicism and Impressionism, it is impossible to consider the merits of either, whether in the context of their own times or against current notions of aesthetic value. That understanding also is essential to inform a further consideration of the debates that raged in

the mid- and late 1800s, during which time an aesthetic transition occurred and Impressionism replaced Neoclassicism as the prevailing aesthetic not only in France but throughout much of the Western art world.

Greer (1997) writes of helping the student to think as a practitioner of the art discipline might think. In the context of art history, his goal is for the student to think in the manner of an art historian:

> Art historians consider works of the past that physically exist in the present, in the process discovering not merely the work's present place in the world of art but also the work's place in the art world of the past and, perhaps, also its place in the various historical periods through which it has passed. The art historian might ask, for example, how a Grecian kouros was viewed in ancient Greece, then in Renaissance Italy, and now in late 20th-century America. (p. 25)

It is not difficult to see immediately how interconnected are the studies of aesthetics and art history. Indeed, when the student begins to take on the role of art historian, the task becomes richly multidimensional. Art historians must go beyond art, as must aestheticians, to connect art to culture, both in general terms and as expressed by individual societies. The questions of time and place in art history invariably are connected to particular times and particular places. Prince Charles's aesthetic quarrel with modern British architecture has a specific focus on England and often more particularly on London. Goldberger (1998) writes that "London, for a while, seemed to be the world capital of concrete slabs. In Charles's second major speech on the subject, he declared that modern architects had done more damage to London than the Luftwaffe" (p. 55). Thus aesthetics and art history in this example find ties to history writ large and specifically to the consequences for London in a post-World War II framework. A teacher seeking to place art history in the broader context of the school disciplines could hardly ask for a better lead-in.

This connectedness, after all, is Greer's (1997) central point. If art is to be considered as a "basic," then the art disciplines must connect both among themselves and with the other basics of the school curriculum.

## ART CRITICISM

The role of art criticism is to inform people (including artists, as Greer, 1997, notes) about the meaning and significance of artworks. Writes Greer, "The niche of the art critic is in increasing understanding and ap-

preciation of art by illuminating the cultural and societal values reflected in it" (p. 24). In other words, the art critic *applies* the perceived current aesthetic values. And so aesthetics and art criticism are as inextricably linked as aesthetics and art history.

Art criticism must draw on both aesthetics and art history for criteria. Rewald (1985) gives this example:

> "When an artist undertakes his work," Heinrich Wölfflin observed, "certain optical conditions present themselves to him by which he is bound. Not everything is possible at all times. Vision has its own history and the revelation of those optical categories should be considered as the primordial task of art history.". . .
>
> The optical conditions by which the Impressionists were bound were not those practiced by the darlings of the official Salon . . . but those which had been established by a few selected predecessors, in whose footsteps they decided to follow. It seems permissible then to elaborate on Wölfflin's statement by saying that during the middle of the last century certain optical conditions presented themselves to the artist *between which he had to choose.* (pp. 188-189, italics in original)

The criteria for art criticism are drawn, therefore, from questions of *which* aesthetic, based on *what* history.

To move this point into more recent times, one might consider the controversies raised over questions about "immoral" art. Photographs by Andres Serrano and Robert Mapplethorpe, for example, raised the ire of the conservative cadre in the U.S. Congress, whose volleys left shards in several fundamental questions: Is it art? Can art be immoral? Is *this* art immoral? and Should Congress fund immoral art? Certainly these are more than simple questions of artistic form—Wölfflin's "optical conditions" of artistic expression on a superficial level. They go to a deeper level imbedded in the phrase "optical conditions," meaning one's view of the world and how it can, or should, be expressed in art.

Art criticism expresses cultural aesthetics, but it also is infused (tainted?) by other societal considerations. Larson (1997), writing the last report to be issued by the National Endowment for the Arts under Jane Alexander's leadership, amplifies this point:

> Ever since the furor that broke out over the photography of Andres Serrano and Robert Mapplethorpe in 1989, scarcely a month has gone by in which the art world was not visited by one storm or another. Some of these tempests were more of the teapot variety, certainly, having much more to do with the immediate demands of a re-election campaign, and with the shallow, often manipulative nature of the mass media, than with legiti-

mate differences of aesthetic opinion. These were political squabbles, in other words, masquerading as cultural debates, and serving neither politics nor culture in the process. (p. 67)

But, says Larson (and this is a crucial point in the effort to move art to the heart of the school curriculum), "That these disputes exist at all says something about the power of art, about the role of the artist in our society, and about the perceptions of Americans of artists in their midst" (p. 67).

## ART PRODUCTION

Art production, or studio art, has been the heart of most art education practice in this century. The guiding notion behind the philosophy of "creative self-expression" was that students needed to express themselves through art, not to study art in terms of aesthetics, art history, or art criticism. *Doing* was the thing—and still is in many classrooms.

But in isolation, what this focus accomplishes is to promote (not merely to permit) a shallow view of art as almost wholly self-referential and self-serving and thus ignores the larger purposes of art. One main larger purpose is to engage the observer. A character in Rebecca West's *The Court and the Castle* (1958) comments that "any authentic work of art must start an argument between the artist and his audience," a sentiment that is not far off the mark in DBAE theory. Self-referential art cannot get past the frame.

Art production is about more than pushing around paint or clay. Making art that gets past the frame sits squarely in a context that is composed of the current aesthetic and the given work's predecessors and contemporaries (its place in art history). The work that results will be critiqued not merely from a technical standpoint (itself shaped by the current aesthetic), but also as a representative or counterrepresentative of its time.

Teachers of art will recognize that this view of studio art goes beyond what is often taught to students. The young artists (and these are all children and adolescents) in most elementary and secondary schools more often experience critiques of their work that are confined to the use of line or shape or color, without reference to how the work relates to the art being presented by professional artists working in or against the prevailing aesthetic. If this narrow critique is expanded by their art teachers, they are lucky. No such enlarged vision is likely from other teachers or parents who have, in most cases, been taught in the limited

schema of "creative expression" themselves. That is precisely the point that Greer (1997) makes. Students should be learning to work *as artists work,* learning to work beyond the frame; and to do so they must be given the tools to discover Wölfflin's "optical conditions" for themselves.

I am reminded of what Picasso is reported to have said in explaining why a painting by Renoir in his apartment was hung crooked: "It's better like that, if you want to kill a picture all you have to do is to hang it beautifully on a nail and soon you will see nothing of it but the frame. When it's out of place you see it better" (quoted in Roland Penrose, *Picasso: His Life and Works,* 1958). Art needs to move out of the classroom, the better for students to see themselves and their work against the background of the day's aesthetic values and the art of the past and the present. Art production cannot be fully successful without reference to aesthetics, art history, and art criticism.

## INTEGRATED ART DISCIPLINES IN ACTION

The preceding paragraphs offer a schema that may seem daunting in application. How can elementary or middle school or high school students be expected to undertake work in the manner of the professional artist, aesthetician, art historian, or art critic? An example or two may be useful.

In an article for *School Arts,* William Detmers (1997), a University of Arkansas art professor, describes a project that he developed with Sandra Eccles, an elementary art specialist, involving the weaving together of art making with African American cultural heritage. The heart of the project was creating animate characters of found and painted driftwood. But that was not where the project began, nor where it ended. Writes Detmers,

> We discussed the traditions and images of both the African and Native American cultures, and examined African American craft and folk art traditions in the U.S. Then, using the notions of body painting, tattoos, and geometric designs used by African cultures, and the idea that a natural form can be seen to resemble a person or an animal, the students began to collect driftwood and look for "spirits" in the wood. Any suggestion of animate form, either human or animal, in the wood was sought. (p. 25)

The editors of *School Arts,* who have become quite standards conscious, inserted in the article a convenient box indicating that the project described by Detmers exemplifies the national standard, "Students differ-

entiate among a variety of historical and cultural contexts in terms of characteristics and purposes of works of art" (p. 25). This is helpful but incomplete. Indeed, an essential element is that Detmers and Eccles's students follow a practice of working artists in drawing from both familiar and unfamiliar cultures.

Gerry Hargrove (1997), a guest columnist for the *Detroit News,* wrote in an online piece, "Imagine my delight, as a novice collector of African and African American art, to ascend the steps of the Picasso Museum entrance and be greeted with many of Picasso's abstract paintings and sculptures juxtaposed to African tribal art." Picasso, although one of the most famous to do so, is hardly alone among artists in his conscious exploration of unfamiliar cultures and cultural aesthetics in the endeavor to express himself and to create a new aesthetic. A creative teacher might readily connect a lesson such as Detmers's to the work of other artists and other times and cultures. As Detmers (1997) points out, "The students not only developed awareness of their cultural heritage but also they learned where to look for information about that heritage." He continues, "This cross-cultural approach to art would benefit all students," which is precisely the aim of DBAE. "Further," writes Detmers, "the project can be integrated into the general curriculum to connect with social studies, music, drama, and language arts (storytelling)" (p. 25).

The interconnecting of the art disciplines with other disciplines in the core curriculum will be further explored in Chapter 6. For the moment, it will be more efficient to confine the discussion to the four art disciplines. In that context, what Detmers (1997) describes nicely exemplifies, in part, Tom Anderson's (1998) notion of teaching aesthetics as critical inquiry. Anderson suggests that aesthetics in an educational context be defined as critical inquiry "in which students actively participate in the process of asking questions and developing answers using the strategies of professional aestheticians" (p. 49). The questions and answers, Anderson suggests, should help students focus on four points of inquiry: meaning and value in art, how art is discussed, the nature of the aesthetic experience, and beauty. The first two points draw heavily on art criticism as the staging area for aesthetics.

Anderson's (1998) instructional tactic is to put students to work devising the questions and then searching for answers, rather than teachers posing questions for the students to answer. By engaging in this process, the students also formulate theories, arguments, and criteria for judgment—all activities engaged in by professional aestheticians.

George Geahigan (1998) expands on the notion of critical inquiry by drawing on John Dewey's six-stage schema (based on Dewey's *How We Think,* 1933; and *Logic: The Theory of Inquiry,* 1938). But Geahigan's emphasis is less procedural than conceptual:

Instead of formulating procedures for students to follow, educators need to turn their attention to identifying conditions that will promote thinking and reflection about works of art. Educators need to design instructional activities so that students become aware of the problems of meaning and value inherent in works of art. (p. 15)

Geahigan suggests that this can be accomplished when teachers use three different kinds of instructional activities. He describes these activities as

1. Personal response to works of art
2. Student research activities
3. Concept and skill instruction

*Personal response to works of art*, suggests Geahigan, is a means of getting students started on critical inquiry by helping them to realize "that the works they are studying present problems of meaning and value" (p. 14). This notion parallels Anderson's (1998) instructional tactic: setting students to work posing questions and seeking answers. Geahigan amplifies this strategy by suggesting that students can be further stimulated by confronting their opinions with contrary opinions and by asking them to compare related works of art.

*Student research activities* are a natural complement; implicit in posing questions is the search for answers. Those answers may be derived in part from self-exploration ("How do I respond to this work?") but, in part, they also must be found in an examination of related works, both contemporary and historical. What antecedents, for example, can be found among the African-inspired works of Picasso that anticipate or relate to the work produced by students in Detmers and Eccles's lesson (Detmers, 1997)?

*Concept and skill instruction*, according to Geahigan (1998), allows teachers to teach aesthetic concepts "in order to enlarge and refine perceptual response" (p. 14). But it is not too great a leap to enlarge, as well, Geahigan's critical inquiry model to encompass concept and skill instruction that cuts across all four of the DBAE disciplines. Again, Detmers (1997) offers a practical connection in a cross-cultural lesson that ties in aesthetics, art history, art criticism, and art making.

This example is indicative of the variety—an almost infinite variety—of ways that the four art disciplines can be connected. The tasks of the effective art teacher are, first, to ensure that the curriculum for art education has sufficient breadth to include all of the disciplines

and, second, to provide instruction that offers students sufficient depth of experience in each discipline so that a well-rounded art education is achieved. Clearly, a multidimensional, holistic approach to these tasks is likely to be more successful than trying to compartmentalize the disciplines.

## CURRICULAR AND POLITICAL REALITIES

Earlier in this chapter, I suggested that curricular and political realities have forced DBAE to "evolve" from its base in theory to various forms of practical application. It may be useful to discuss some of these realities before passing on to other elements in the critical convergence.

One current of change that is helping to move DBAE to the fore is the way in which teachers are being taught to teach art. Throughout the 1980s and 1990s, DBAE theory made inroads into art teacher education, and the heavy, nearly exclusive, emphasis on art making for creative self-expression has been sliding out of fashion. Formerly, most future art teachers were required to take only token coursework in art history and virtually no concentration in aesthetics or art criticism at the under-graduate level. Over the past 15 to 20 years, this pattern has been chang-ing—"evolving"—as well, with the result that DBAE is filtering into the schools with new art teachers as well as though professional develop-ment for veteran teachers.

Aesthetic education, in particular, is beginning to experience an aca-demic rebirth, although it is, in part, a reaction to disillusionment over cultural studies (Heller, 1998). For some time, only cultural conserva-tives have had much to say about aesthetics and then only to assert a particular canon. Now a new generation of scholars has taken up aes-thetics, not in the old narrow sense, but marrying aesthetic criticism to cultural contexts and concerns. These scholars are reopening a debate that can only enrich the teaching of art.

Nor is the evolution exclusive to visual arts education or, indeed, to arts education (or the humanities) more broadly. In the teaching of Eng-lish, for example, 20 years ago and more the main emphasis in teacher education was on the teaching of literature. This would be the equiva-lent to history and criticism in art. Very little emphasis was placed on writing—"literature making"—until the writing-as-a-process move-ment of the 1980s picked up steam. Nowadays future English teachers are getting a healthy dose of writing instruction to complement their background in literature.

Moreover, aesthetics in literature are being debated once again. According to Heller (1998),

> And in an era of Oprah's Book Club and the Modern Library's Top 100 novels, the general reader wants help from experts in making judgments. "The public doesn't much understand—and isn't much interested in supporting—a humanities that doesn't address aesthetics," says Giles Gunn, a professor of English and global and international studies at the University of California at Santa Barbara. (p. A16)

Both of these multidisciplinary approaches, within art and within English, are creating new curricular realities that are in step with the social and political realities of today. They also can be seen in a larger context as curricular responses to the currents of postmodernism and constructivist theories of learning and teaching, which I take up in Chapters 3 and 4, respectively.

And, as should be clear from the discussion in Chapter 1, the whole notion of a discipline-based approach to art education has gained new validity through the national standards movement, which also is constructing new political and educational realities.

## REFINING THE MODEL

In Chapter 1, I posed three questions to assist in developing a model for thinking about art education from the standpoint of a critical convergence of ideas. These questions centered on *universals, the community,* and *the individual* (with reference to the student, rather than the teacher, for the most part):

1. What are the "universals" that must be included in art education?
2. What are the local (school, community) considerations, such as culture, norms, and expectations, that must be included in art education?
3. What "space" in art education must be defined in which students can address individual needs, interests, and abilities?

These questions were posed against the background of standards in Chapter 1. The next step, adding the curricular framework of discipline-based art education to the model we are constructing, is to consider these three questions as they apply to aesthetics, art history, art criticism, and art production. At this point a simple chart of additional questions may prove to be a useful device for beginning to think about

**CHART 2.1**  Curricular Considerations

| Aesthetics | Art History | Art Criticism | Art Production |
|---|---|---|---|
| *Universals.* What are the aesthetic "norms" in today's society? What should students learn about how "beauty" is defined in art? | *Universals.* What is the canon? Which canon? How are the "universals" of art history determined? Who makes the determination? | *Universals.* How is criticism expressed? What factors inform the aesthetic? What other factors, such as politics, affect art criticism? | *Universals.* What are the standards for art making? What general knowledge and skills should all students acquire? |
| *Community.* How are general aesthetic norms modified locally? What exemplars exist in the community that students can use as reference points for the community's aesthetic values? | *Community.* What evidence points to local art history, such as architecture, museum collections, and so on? What aesthetic factors have influenced the community's art? | *Community.* How is art criticism localized? Who are the arbiters? What factors inform their critiques? | *Community.* How can students be involved in the aesthetic life of the community through art production? |
| *Individual.* How do personal preferences and an individual sense of the aesthetic enter the classroom experience of the visual arts? | *Individual.* In what ways do students reflect personal knowledge of art history? How does art history inform students' perceptions and perspectives for art making? | *Individual.* By what "optical conditions" (cf. Wölfflin) does the student work? What mechanisms exist to support and encourage peer criticism and self-critique? | *Individual.* What guides student art making that "gets outside the frame"? How is art production tempered by aesthetic, critical, and historical information? |

this new set of considerations (see Chart 2.1). Earlier in this chapter I used the term *aesthetic education* in its particular sense of referring to the teaching of aesthetics. Broudy (1964) used the term more generally as a synonym for art education (or, in fact, education in the arts broadly) when he raised the following point:

> When you are trying to get a strategy for persuading school boards to give you money and curriculum time for aesthetic education, I just don't think that you are ever going to get it merely on the basis of the aesthetic enjoyment you promise. They will want to know the extra-aesthetic side of the program, its effect on the person and on the society. (p. 118)

Broudy's comment brings me back to the central theme of this chapter, which is developing, evolving, or adopting a curricular framework that

can serve to move art education from the periphery of the school experience for most students back to its rightful place at the core of schooling for *all* students. That movement will take place only if art education concerns itself not merely with art for art's sake but also with the place of art in the lives of individuals, communities, and society at large. Discipline-based art education, with its balanced inclusion of aesthetics, art history, art criticism, and art production, offers such a framework that not only is gaining wide philosophical acceptance but increasingly is being implemented in schools.

## REFERENCES

Anderson, T. (1998, September). Aesthetics as critical inquiry. *School Arts,* pp. 49-55.

Broudy, H. S. (1964). The structure of knowledge in the arts. In S. Elam (Ed.), *In education and the structure of knowledge.* Chicago: Rand McNally.

Bruner, J. S. (1960). *The process of education.* Cambridge, MA: Harvard University Press.

Detmers, W. P. (with Eccles, S.). (1997, February). Wood spirits. *School Arts,* pp. 24-25.

Elementary and Secondary Education Act of 1965, Pub. L. No. 89-10.

Geahigan, G. (1998, September). Critical inquiry: Understanding the concept and applying it in the classroom. *School Arts,* pp. 11-16.

Goldberger, P. (1998, July 13). A royal defeat. *New Yorker,* pp. 52-59.

Greer, W. D. (1997). *Art as a basic: The reformation in art education.* Bloomington, IN: Phi Delta Kappa Educational Foundation.

Hargrove, G. L. (1997, February 6). Expressions of African art: Picasso pieces influenced by abstracts, colorful designs of African art. *Detroit News* online: http://detnews.com/1997/detroit/9702/06/02020045.htm

Heller, S. (1998, December 4). Wearying of cultural studies, some scholars rediscover beauty. *Chronicle of Higher Education,* pp. A15-A16.

Larson, G. O. (1997). *American canvas.* Washington, DC: National Endowment for the Arts.

National Art Education Association. (1995, October). *A vision for art education reform.* Reston, VA: Author.

Rewald, J. (1985). *Studies in Impressionism.* New York: Harry N. Abrams.

Wilson, B. (1997). *The quiet evolution: Changing the face of arts education.* Los Angeles: Getty Education Institute for the Arts.

# 3

## THE INFLUENCE OF
## POSTMODERN PERSPECTIVES

In Chapter 2, I suggested that an integrated disciplines structure—drawing on discipline-based art education (DBAE) theory—might serve as a conceptual framework for art education reform and renewal. Such a framework would be as useful in the early and middle grades as it would be in the high school, where the disciplines also might be appoached in separate classes for some students. The same is true for higher education, whether the purpose is to train artists or art teachers.

Given this conceptual framework, the next reasonable question is, How might educators think about a curriculum that is to be implemented through an integrated disciplines structure? What influences bear on this curriculum? This is the next part of our elephant of critical convergence.

To be effective, a curriculum for art education must draw from the sociocultural milieu in which students and teachers live and work. This diverse environment includes elements that are familial, cultural, social, economic, linguistic, and racial. How these elements are viewed may be shaped by any number of perspectives. I argue in this chapter that the most pertinent perspectives for art education in the 21st century can be gathered under the rubric of "postmodernism." Therefore, my goal in this chapter is to examine, first, the concept of postmodernism, in part by exploring the contrasts between postmodernism and modernism; and, second, to suggest in that context how the art education curriculum of the 21st century might be built on postmodern perspectives.

## DEFINING POSTMODERNISM

It is only reasonable, first, to dispense with the nonsense that has overtaken the term *postmodern*, which has been overused and abused. Jeffrey Wasserstrom (1998) makes this point in a clever piece titled "Are You Now or Have You Ever Been . . . Postmodern?" Wasserstrom is not off the mark when he contends, "Postmodernism now qualifies as one of those words whose linguistic career resembles that of a kitchen sponge" (p. B4). A term that can be used for every purpose soon becomes useful for no purpose. Thus I am concerned with defining postmodernism, rather than taking it at questionable face value.

With the publication of his 1977 book, *The Language of Post-Modern Architecture*, Charles Jencks became a primary definer of postmodernism. The language that he used to describe the then-new currents of thought in architecture has been adopted by various disciplines, arts and otherwise. That language also has been enlarged by other theorists and practitioners. But it is useful to begin with Jencks, who wrote that "as even the remaining Modernists now grant, we live in a post-modern era, the information age where plural cultures compete and there is simply no dominant cultural style or ethos" (1977/1991, p. 10).

Jencks introduced two seminal concepts: *pluralism* and *complexity*. Each of these concepts merits a brief description as it applies to the visual arts in general, rather than specifically to architecture. Readers who are familiar with other disciplines— say, literature or history—will find relevance in the concepts as they apply to those fields of study as well as to the disciplines of art.

*Pluralism* can be defined as the presence of multiple styles of art, in many cases derived from multiple cultures. Although this definition is accurate, it is somewhat simplistic. In fact, cultures in today's world also are broadly pluralistic *in themselves*. Multiple styles flow not only from different cultures but also from within the same culture.

In the past, a culture observer—such as an art historian—might note a broadly cohesive cultural style at a given time. Painters working during a particular period within a definable culture might produce works of very similar character. One can observe this cultural unity in the Dutch painting style of the 17th century, for example. A viewer of the paintings from this period will find little to distinguish one artist from another, apart from the exceptional painter, such as Rembrandt.

Instances of broad cultural unity of style are rarer today (although one certainly can find "schools" of painting or sculpture and genre similarities). A reason for this rarity is alluded to by Jencks (1977/1991) in his reference to "the information age." Influences from outside the

culture affect the cultural style, which then becomes plural: *styles.* The culture may produce any number of styles, all of which may be identified with the culture but none of which predominates, or styles may become highly individualized to the point that no definable cultural style can be seen. Three centuries ago and earlier, outside influences might affect an entire cultural style, thereby creating a new style, a new unity. Wylie Sypher discusses the cyclical nature of stylistic change in his influential 1955 book, *Four Stages of Renaissance Style* (1955/1978). Today, however, outside influences are more likely to effect stylistic changes by individual artists, rather than among the culture's artists generally. Hence there is no "Dutch style" nowadays, just as there is no "American style" or "English style." Western cultures, and to an increasing extent non-Western cultures, have become internally pluralistic.

*Complexity* is the partner of pluralism. When cultural unity of style gives way to plural styles, that pluralism is seldom the result of simple, linear permutations. Rather, it comes by way of a complex mix of influences.

What has happened during the evolution of the postmodern period (which I loosely define as the last quarter of the 20th century and still ongoing) perhaps can be seen more clearly in an example of a single artist. Picasso, the penultimate modern artist, is prototypical of postmodernism in general. When one looks at the huge body of Picasso's work, one observes not a straightforward development (the old term would be "progress") from mannerist to abstract expressionist. Rather, Picasso's work exhibits a wildly erratic (which is to say, individualistic) series of transformations. His "dissection" of viewpoint (multiple views of a single face; for example, *Standing Woman,* 1958) can be traced, it has been conjectured, to having witnessed a brutal autopsy as a teenager, more than a half century earlier. His Blue Period paintings of 1901-1905 may have been influenced by the suicide of his close friend, Carles Casagemas, in 1901 (Mailer, 1995). These influences are not cultural but highly individual and highly complex. Nor are they necessarily immediate responses to stimuli; they arise out of a process of germination. And they are not the same influences felt by, say, Klee or Kandinsky, who were working at the same period as Picasso but in very different ways. (At the same time, part of this complexity also is the intermingling of the individual with the cultural. Picasso's *Guernica,* painted in 1937, is a response to the Spanish Civil War, which also influenced many other artists and writers.)

The erratic development, or repeated transformations, of personal style by Picasso can serve as a metaphor for the larger transformations of cultural style. In contrast to earlier periods of cultural unity, today's

individual artists and small groups, or schools, of artists exemplify the complexity of pluralism within cultures. No postmodern "cultural style" can be defined in the singular, nor can any pluralistic definition be construed as unidimensional, either simply or linearly derived from some single predecessor. Jencks (1977/1991) sums up this point in his characterization of urban architectural settings:

> During the industrial age Modernism became the most important epis-teme; while in the post-industrial period none of these competing cul-tures—High, Low, Traditional, Mass, Pop, Ethnic or Other—speaks for the majority of urban dwellers. Most of the time in the huge megalopolis we are all minorities—yes, even those who have cornered what used to be called "the ruling taste," the Establishment. (p. 10)

This point applies to all of the visual arts, of course. The disunity of cul-tural style is no less apparent in painting, sculpture, or ceramics than it is in architecture.

To put a finer point on the essential transformations of postmodern-ism, it may be helpful to contrast it with modernism. The term *modern-ism* characterizes much of 20th century Western history, certainly from about 1900 until the mid-1970s—and not just in the visual arts. Modern-ism was an outgrowth of converging 19th century "isms," such as hu-manism, rationalism, and individualism. David Elkind (1995) suggests that these "isms" led to three basic beliefs about modernity: progress, universals, and regularity.

As applied to the visual arts, *progress* is the belief that one style "de-velops" into another, more refined, more perfect, style. The Impression-ists Paul Cézanne and Georges Seurat are the "ancestors"—to use H. W. Janson's term—of modernism in the form of the abstract movement. Again, this is the stylistic stages notion of Sypher (1955/1978). This idea of the "perfectibility" of style is complemented by the notion that cer-tain *universals* of style can be defined—for example, the golden section or two-point perspective—and that adherence to such universals is a necessary precondition for excellence. *Regularity*, like progress and uni-versals, is an essential goal; it implies linear development, uniformity, consistency, and similar traits. "Modern" schools are marked by archi-tectural regularity; an example would be the "egg carton" floor plans of many school buildings erected during the 1940s through the 1970s.

This compartmentalized, virtually universal concept in school de-sign mirrored the prescribed, lockstep, compartmentalized, sequential curriculum through which students made "progress," largely by the ac-cumulation of information. The modernist school canon is regular and

uniform; all students study roughly the same authors, artists, and ideas at about the same time, whether they attend school in New York or Arizona. High school freshmen take first-year algebra; sophomores read *Macbeth*. The modernist concept of learning was based on behaviorist theory: Children "progressed" by acquiring (or accumulating) knowledge, rather than by creating meaning, which is the constructivist view emerging over the past quarter century. (I say more on this point in Chapter 4.)

Postmodernism contrasts dramatically with modernism. Indeed, contends Elkind (1995), "the [postmodern] movement represents a fundamental paradigmatic shift in our abiding world view" (p. 8). *Difference* is the counterpart of progress, *particularity* the counterpart of universals, and *irregularity* the counterpart of regularity. In the postmodern sociocultural milieu, Elkind suggests, we value more the articulation of sociocultural differences rather than linear social progress, cultural particulars rather than universals, and the irregular as being "legitimate and as worthy of exploration as the regular" (pp. 9-10).

This is the transition with which educators, parents, and policymakers are struggling on the threshold of the new millennium. And so, to understand how postmodern influences must help to shape the school curriculum for art education, it will be useful to explore further some of the contrasts of modernism versus postmodernism. Four categories are pertinent for this chapter:

The Industrial Age versus the Information Age

The "Melting Pot" versus Multiculturalism

Nationalism versus Globalism

The "Traditional" Family versus the "Permeable" Family

A fifth category—Behaviorism versus Constructivism—is more concerned with instruction than curriculum. Therefore I take up this fifth contrast as the core discussion in Chapter 4.

## THE INDUSTRIAL AGE VERSUS THE INFORMATION AGE

If postmodernism is best understood by contrasting it with modernism, then it also may be easiest to understand the fundamental processes of the Industrial Age by contrasting it with its predecessor, the Agrarian Age.

The Industrial Age in the West began in late 18th-century England with the Industrial Revolution. At that time there was a massive shift from home-based, hand manufacturing—part of the agrarian economic culture—to mechanized, factory-based production. This shift was the result of a critical convergence of new technology, inventions, and commercial manufacturing strategies that would both speed the production of uniform goods and lower their cost. The result was a complex of radical socioeconomic changes that transformed England and the rest of the Western world and eventually most of the globe. Thus the Agrarian Age gave way to the Industrial Age.

The metaphor of the Industrial Age is the assembly line, which is symbolic of linearity in general. For most Americans, the cultural image of the Industrial Age is the automobile assembly line, in particular, and the picture in most people's mental archives is probably of Henry Ford and his Model T. Ford's automobile assembly line was replicated in the sequential curriculum that became standardized in American (and most Western) education. The Industrial Age model of curriculum employs a parts-to-whole, inductive approach. Examples include the phonics approach to reading, by which students learn letter symbols; then letter sounds; then small words, larger words, and finally phrases and sentences. In the visual arts, this approach requires students to study color relationships, tints and hues, color mixing, lines and shapes, and so on before attempting to paint an actual painting. This is a "fundamentals first" curriculum, in contrast to an experiential (or deductive) approach, in which students first paint to gain a holistic sense of painting and then analyze the skills that need to be refined through attention to basic processes. In simple terms, students following an Industrial Age model would be *given* the knowledge that red and yellow make orange, rather than discovering that information through mixing the colors on their own.

The Information Age has turned the Industrial Age on its head and shaken it. Returning to Elkind's (1995) concepts of postmodern "difference," "particularity," and "irregularity," these concepts are best symbolized by how a computer can be used to gather information. The computer, in contrast to the assembly line, is a random processor, rather than a sequential process. Consider how one navigates through online information using the Internet. When one "surfs" or searches for information, one leaps from topic to topic according to relational links, not by means of progressing through some predetermined sequence. The "browser" is aptly named, as the term conveys an air of randomness. But such randomness is not without purpose.

Think of it this way: When one reads a book, one normally starts at the front and reads page after page, sequentially. This is the Industrial Age approach. But what if I found an idea on page 12 and could immediately jump to a related idea on page 37, without plodding through pages 13 through 36, which have nothing to do with the idea I want to pursue? The computer's electronic linkages, which can be randomly activated according to the needs and interests of the user, rather than in a rigid sequence, offer an entirely different manner for gathering information. This is the Information Age approach.

In the Information Age, students acquire knowledge in nonlinear ways, in part because the "knowledge explosion" of the 20th century has diminished—some would say destroyed—the viability of traditional, often culture-bound, canons of knowledge. Humans now have access to more information—and more diverse kinds of information—than ever before. Cultures collide and commingle, and the results are highly individualistic, pluralistic, and complex. The traditional canon becomes constraining to the point of strangulation and so must be abandoned or, at least, adapted and opened.

Conservative educators and curriculum theorists cling to the Industrial Age model because it offers stability and reifies dominant culture ideals. But, as Jencks (1977/1991) pointed out some time ago, in the postmodern era, "we are all minorities" of one type or another. Certainly, in some ways the so-called dominant culture has disappeared and been replaced by multiple cultures coexisting (sometimes in conflict) in the same socioeconomic and geographic space.

The radical view that exemplifies the Information Age approach was articulated by Paulo Freire even before the publication of Jencks's (1977/1991) book. In his famous work *Pedagogy of the Oppressed* (1970), Freire states unequivocally that the "starting point for organizing the program content of education . . . must be the present, existential, concrete situation, reflecting the aspirations of the people" (p. 86). More recently, Elliot Eisner (1990) pondered whether the essentially conservative voices of government, expressed in the plethora of standards (which I reviewed, in part, in Chapter 1), ought not to be countered by the diverse voices of curriculum scholars. Some of these scholars, such as the reconceptualists, Eisner suggests, "would continue to remind us that it is personal experience that really counts and that other starting points for curriculum are essentially coercive or irrelevant" (p. 526). When Eisner concludes that these diverse voices would produce "not a symphony, but a cacophony," he asks, "Would this be bad? I think not."

The Information Age is one manifestation of postmodernism. Where the emphasis in the Industrial Age was on *product*, the emphasis in the Information Age is on *process*. Henry Ford's Model T automobile was available "in any color as long as it's black," as the old saying went. Uniformity (universality and regularity) was the hallmark of that age, and "progress" was made by turning out more and better products. In education, students made progress by acquiring an ever greater share of the canon, the sanctioned knowledge of the dominant culture.

In the Information Age, students engage in learning as a *process* of existential exploration, making meaning by acknowledging and articulating sociocultural differences and by investigating particular information based on individual interests and needs. The construction of individual meaning (irregularity), rather than the acquisition of canonical knowledge, is to be prized—and, from a socioeconomic standpoint, will be as valuable a commodity as canonical knowledge in the marketplace of ideas as well as in economic commerce.

## THE "MELTING POT" VERSUS MULTICULTURALISM

About a hundred years ago, a notion arose in the United States that the nation would be strengthened by greater cultural cohesion—in short, by the creation of a singular "American" culture. For the nation of immigrants, this notion meant that most newcomers would have to abandon much of their home culture to adopt this new "American" culture, a largely Euro-American one with little room for nonwhite, non-European, non-Judeo-Christian, and non-English-language ideas. This was the "melting pot" notion. Everyone would give up their diverse cultural, ethnic, and linguistic identities to "melt" into a cohesive, new American identity.

Contrast this notion with the previous era, when immigrants to the New World might fairly easily retain their cultural identity in neighborhoods and enclaves that were ethnically, linguistically, or racially distinct. The remnants of these enclaves can still be seen: Little Italy, Harlem, Chinatown. The abandonment of this distinctiveness was urged on, in part, by technology: greater facility of communication—telephone, radio, movies, television—and transportation—automobiles, urban transit, airplanes. Such facility increased contact between neighborhoods and ethnic enclaves and increased cross-cultural commerce, which necessitated a common language and a common framework of business practice.

Another urging, however, was the pressure of conflict that came from both internal and external sources, including World War I, women's suffrage, the Great Depression, World War II, the Korean conflict, and the civil rights movement. All of these great pressures on the nation as a cohesive union were seen to be reasons for "melting" into a single society, marked particularly by national allegiance and patriotism. For example, before World War I many schools taught classes in native languages such as German, and there were German Lutheran and German Catholic churches that used the German language for worship. All of these language uses virtually disappeared as a result of World War I. The immigrant German population "melted" into the "American" cultural stew. (The Germans were lucky. The Japanese, whose ethnic, racial, and linguistic differences from the "American" mainstream were more visible, fared less well; they were herded into the infamous internment camps of World War II.)

But it did not take long for the melting pot notion to give rise to new problems. National unity had been built on the destruction of individual and ethnic group identity. Ricardo Garcia (1998) writes,

> Second-generation immigrant children grew up learning only English, and soon grandparents were unable to talk to grandchildren because they spoke different languages. Traditional customs were set aside; children adopted "American" customs, dress, and manners, often to the dismay of their parents and grandparents. Generation gaps became cultural gaps as well. (p. 78)

Thus in the wake of the civil rights movement and all the rest, there arose a countermovement in the 1970s under the term *multiculturalism*. Garcia continues,

> *Multiculturalism* is the common term; the metaphors are the patchwork quilt, the cultural salad, the global roots stew. All are apt. In a stew the ingredients work together, each lending its essence to the savory broth of the larger community. At the same time, the ingredients also retain their individual identities: the potatoes are still potatoes, not carrots or onions or beef. Thus in the diversity of a multicultural society, individuals learn how to communicate and work with one another across cultures. They find common ground. But they do not become one another; they retain their individual cultural identities. (p. 78)

Multiculturalism harkens to the postmodern diversity of the Information Age, in which individuality once again is asserting itself and culture group identity has again become important. Conservatives

hold up the critical need for a national identity—an "American" identity—as a stop sign against the reemergence of diversity for the 21st century, because they fear national disunity fostered by multiculturalism. Radical multiculturalists give this fear short shrift. But both extremes are countered by the cultural centrists who see balance as the best course. Henry Giroux (1996) states the centrist case well when he says that educators must provide students "with the opportunity to develop the critical capacity to challenge and to transform existing social and political forms, rather than simply adapt to them" (p. 690). But, he continues,

> It also means providing students with the skills they will need to locate themselves in history, to find their own voices, and to provide the convictions and compassion necessary for exercising civic courage, taking risks, and furthering the habits, customs, and social relations that are essential to democratic public forms. (p. 690)

Casting this section in either-or terms perhaps stretches the point I am trying to make. Indeed, for schools, the constituent diversity of which also includes the spectrum from conservative to radical, the centrist position is probably the most workable. Yes, certain elements of the school curriculum must be common; there is need for a *limited* canon, just as limited goals and standards can be helpful. But the traditional canon is far too narrow and must be expanded to let in the underrepresented. I harken again to Jencks's (1977/1991) dictum that "we are all minorities." Therefore educators must balance the need for common ground with the compelling diversity not merely among students but in the general population of the nation.

## NATIONALISM VERSUS GLOBALISM

In the previous section I touched on nationalism in the context of America's melting pot society. The first half of the 20th century was marked by two major wars punctuated by a massive economic depression, all of which strengthened a rebounding nationalism. In the backward glance of history, the ascent of nationalism from the turn of the 19th century is hardly surprising. Wars tend to be unifying when the population perceives a threat to themselves. (The converse also occurs. National discord over the Vietnam War arose because a large portion of the population did *not* see what was happening in Southeast Asia as a threat to the nation.) When outsiders threaten the nation, politicians en-

ergize the population by stirring up national feeling, often by demonizing the enemy. In 1914, when American soldiers trooped off to war in the trenches of Europe, the Civil War, which had so tried the nation's unity, was not very far in the past. Civil War veterans still marched in Independence Day and Veterans Day parades in those days, and they were a living testament to the value of national unity.

But even in the wake of World War I, many in the United States recognized that a global outlook would be necessary for the nation to participate fully in the "progress" of the 20th century. Isolationism and the failure of the fledgling League of Nations did not prevent the United States from moving toward an increasingly global viewpoint again following the World War II-Korean conflict period. During the Red Scare and from then on, America positioned itself as a global power broker and a global peacemaker and peacekeeper. And by the post-Vietnam War era, America had made the paradigm shift in which the League of Nations ideals were reawakened—again, abetted by technology (the Information Age). In spite of conservative stridency and strong conservative political leadership, in the past three decades the United States has moved away from ardent nationalism toward greater globalism.

In the West to date, however, this shift has been more dramatic in Europe than in the United States. A personal story may serve to illustrate my point. In 1958, as one of three children of an American military father, I moved to West Germany with my family. Postwar Germany was then still in the midst of its economic and social recovery, a little more than a decade after the Nazi defeat. From the late 1950s until the 1980s—having lived in West Germany for much of my adolescence, returned to the United States for college and the start of my teaching career, and then gone back to West Germany in 1981 to teach in the American schools for a couple of years—I watched a slow but persistent ebbing away of rigid nationalism in Europe. For most of the time to which I bore witness, on one side of West Germany the border with France constituted a "friendly" checkpoint. Flashing an American passport was all one needed to cross back and forth (except for a brief period in the late 1980s, when a visa for France was needed—the result of a nationalistic tiff). On the other side, the wall between West and East Germany constituted a decidedly unfriendly barrier.

When the Soviet Union disintegrated and the Berlin Wall fell in 1989, globalism swept across Europe like a wave. Germany moved rapidly toward reunification, and the European Union (EU) began opening other borders. When I returned to Germany—no longer "West" Germany—for a visit in 1997, I could drive without interruption into what had been the walled fortress of East Germany. Only a lingering

economic disparity told me where I was: The former East Germany was less Americanized than the West. And, because of the EU, I also could drive freely in the opposite direction, into France, past shuttered border stations that I scarcely noticed. I knew that I had crossed into France only because the road signs suddenly were in French instead of German.

On the other side of the Atlantic, the North American Free Trade Alliance (NAFTA) is an American manifestation of the paradigm shift from economic nationalism to economic globalism. Although conservatives still wave the flag of nationalism, it is clear to most observers that globalism is a tidal wave that cannot be stopped, set in motion by and fully in concert with the postmodern forces of pluralism and complexity.

With economic globalism comes cultural globalism, because the commodities of international commerce often are, or carry, culture markers. During the Roman Empire period, the proliferation of Roman roads brought the cultural artifacts of Rome to the rest of the world, and vice versa. In a very short time, town squares in the cities from Asia Minor to Gaul became virtually indistinguishable architecturally from those on the Italian peninsula. In like manner, the *gummi bären* of my childhood in 1950s Germany are the "gummy bears" that my son munches in 1990s America.

No "commodity" has become more global than the arts, from foreign films and theatrical events to music to historical artifacts and contemporary art. Traveling exhibitions of everything from King Tut's golden detritus to Monet's enormous lily ponds have enlarged the scope of the public's personal acquaintance with the visual arts of the past. This firsthand knowledge is daily complemented by television and motion pictures that awaken public understanding—including the "public" sitting in school classrooms—and increase the potential for creating meaning that includes the arts.

Perhaps no other force has done as much to foster globalism in the arts as computer technology. Using the Internet, teachers and students (and anyone else with computer access) can "visit" museums and galleries almost anywhere on the globe. They can do so with amazing speed and facility, and the information they will find is more diverse and more accessible than many university libraries can provide using traditional forms—presuming teachers and students even have access to them. I take up this "virtual" access to art in some detail in Chapter 5.

My point in contrasting nationalism and globalism is that today's teachers and students are far more likely than their predecessors to see images that represent unfamiliar cultures. Thus the postmodern global influence on curriculum may be taken as pervasive. The influence is

broadly plural and highly complex. Where modernists would offer a prix fixe menu, postmodernists set a banquet, a smorgasbord.

## THE "TRADITIONAL" FAMILY VERSUS THE "PERMEABLE" FAMILY[1]

As a final contrast, postmodernism is dispelling the myth of the "traditional" family. Public lamentations, particularly from the Religious Right, over the demise of the so-called traditional family have played long and loud during the past quarter century. Pundits, preachers, and politicians have leapt on the issue, blaming the supposed death of the traditional family for everything from declining test scores to rising school violence.

What few of these critics realize—and fewer admit—is that the traditional family is a modernist myth. Janice Hamilton Outtz (1993) points out, "The American family is diverse, there is no 'typical' family structure. Instead, there are many work-family patterns and each pattern, or family type, has different needs" (pp. 18-19). The 1950s, *Ozzie and Harriet* ideal family consisting of a working father, a housewife mother, and two or three children—the "traditional" family—never constituted more than 50% of all American families. In the 1950s only 48% of family households were "traditional." During the sexual revolution of the 1960s the percentage actually rose to 50%, but by 1990 they made up only 37% of family households (Outtz, 1993, p. 6).

If "the school is the mirror of society and of the family," Elkind (1995) suggests, then "as society and the family change, so too must the school" (p. 8). That the traditional family has always been less than predominant except in popular myth, however, does not diminish the fact that families *have* changed over time. Those changes also are important to note. According to Outtz (1993),

- In 1990, 24% of families were headed by a single parent; the comparable figure in 1950 was 7.4%.
- In 1970, about 341,000 men headed single-parent families; by 1990 the figure had jumped to 1.2 million.
- In 1991, 71.7% of children under age 18 lived with two parents, but between one fourth and one third were in "blended" families.
- 8 million to 14 million children are being reared in gay- or lesbian-headed families that often go unrecognized as "families" in official data counts. (pp. 8-12)

Outtz concludes, "All of us must recognize the diversity of American families as well as the complexities surrounding the needs of this diverse group. Just because the family is different, does not mean that it is 'bad,' or that it is 'dysfunctional'" (p. 12).

Elkind (1995) refers to this postmodern concept of family diversity as "permeable," meaning that families are composed in various ways, such as through affectional ties between unrelated individuals, *in addition to* traditional ways, such as through marriage and childbearing or adoption. John R. Gillis (1996) echoes this notion when he complains that "researchers' focus on the nuclear family blinds them to the degree to which people turn friends into members of their 'family,' creating new kin that supplement their ties of blood and marriage" (p. A40).

How does this view of the permeable family affect the curriculum for art education? Simply this: The fictional neatness of nuclear modernity must be discarded for the reality of messy postmodernism, because that messiness is a reflection of the real world from which art arises and takes meaning. Film critic David Denby (1996) puts it this way:

> Well-educated American conservatives who vilify popular culture for political ends appear to want entertainment that is didactic, improving, and hygienic.
>
> In a true liberal-arts education, however, children are exposed to many stories, from many sources. They hear about all sorts of behavior—wickedness and goodness and the many fascinating varieties in between—and are taught what a narrative is and what its moral relation to life might be. (p. 53)

Denby's phrase, "conservatives who vilify popular culture for political ends," recalls the heavy criticism faced by the National Endowment for the Arts over its financial support of exhibits of photographs by Robert Mapplethorpe and Andres Serrano. Real life is not conducted according to a neat canon or a comprehensive curriculum. Nor is real art produced by formulas.

What happens in the family or as a result of family dynamics affects children's view of the world. Families, along with schools and other influences, also shape what students determine to be the "real world," from which and with which art and meaning are constructed. Framed in terms of contexts and processes, a postmodern art education curriculum, therefore, must deal with the reality of today's permeable family. Or, as Stephanie Coontz (1995) explains,

We cannot return to "traditional" family forms and expectations that were at least partly mythical in the first place. To help our children move successfully into the 21st century we need to stop organizing our institutions and values around the notion that every family can—or should—have one adult totally available at work and another totally available at home. We have to adjust our economic programs, schools, work policies, expectations of family life, and moral reasoning to the realities of family diversity and the challenges of global transformation. (p. K18)

## REFINING THE MODEL

This chapter on postmodern influences has been more about divergence than convergence, and so it is necessary to say a word or two about that. I have cast the coming together of standards, discipline-based art education theory, postmodern perspectives, constructivist teaching, and new technology as a critical convergence of ideas that may—in my view, should—lead educators to rethink how art is taught at all levels of schooling. Postmodernism, in contrast to modernism, is about pluralism and complexity—the divergence of ideas. It is anti-canonical. Should this not, therefore, argue the opposite, perhaps for a critical *divergence* of ideas? I think not.

I suggested in Chapter 1 that too narrow a detailing of standards at any level will stultify the curriculum and bind instruction to rote, rather than reform. To be effective without being restrictive, standards must be broadly, even loosely, cast to allow for diversity, for plural visions of what art is and how art may be created. Such broad, basic standards are the centrist conductor who allows the musicians freedom to express themselves and yet still deliver up a symphony, rather than a cacophony.

In similar fashion, discipline-based art education theory offers a framework, not a prescription for curriculum. Like the armature of a sculpture, while it provides structure and support, it also must be flexible and capable of being adapted to the needs and the vision of the sculptor. Aesthetics, art criticism, art history, and art production are convenient organizers. They are not rigid compartments.

The question of *universals, the community,* and *the individual,* cast in terms of a postmodern frame of reference, is anchored by the critical convergence. Postmodern universals are pluralistic and complex. Communities are multicultural. And individuals cannot be regarded as

mere types. Thus in thinking about art education it is essential to consider some new questions:

- How can we define curricular "universals," given the complexity of today's society? Who must have a say in the definition? Who ultimately decides? Policymakers? Administrators? Teachers? Parents? Students themselves? How do the themes of postmodernism influence this decision?
- What cultures and traditions compose the character of "the community"? What art is valued? How are cultural influences communicated? How can they be incorporated into the art education curriculum?
- How is "the individual" to be recognized? How are individual differences recognized, accommodated, validated, and valued? What are the roles of culture? Intelligence? Learning style?

These questions, set next to those in Chart 2.1, shade in new ways the portrait we are painting of the blind men's beast, the critical convergence of ideas.

Constructivist teaching, which I take up in the next chapter, reifies postmodernism through instructional practices, with particular attention to the individual. Technological applications, which I discuss in Chapter 5, are new tools for instruction in the art disciplines. New technology extends the constructivist perspective. It does not constrain the curriculum; it liberates it.

The critical convergence of all of these elements should lead educators to think differently about the way art education is approached in elementary and secondary schools. But what they need to think about is not how to codify this new view, not how to bind it to limits. On the contrary, educators—from theorists and arts administrators to classroom teachers—must concern themselves with finding ways to set students free in the pursuit of art knowledge. In so doing, educators become guides, offering road maps and compasses and advice about travel. Such educators do not dictate where students should go; they give them mental equipment and practical tools and encourage them to begin the journey.

## NOTE

1. A more detailed treatment of this topic appears in Walling (1997).

## REFERENCES

Coontz, S. (1995, March). The American family and the nostalgia trap. *Phi Delta Kappan, 76,* K1-K20.

Denby, D. (1996, July 15). Buried alive. *New Yorker,* pp. 48-58.

Eisner, E. W. (1990, March). Who decides what schools teach? *Phi Delta Kappan, 71,* 523-526.

Elkind, D. (1995, September). School and family in the postmodern world. *Phi Delta Kappan, 77,* 8-14.

Freire, P. (1970). *Pedagogy of the oppressed.* New York: Continuum.

Garcia, R. (1998). *Teaching for diversity.* Bloomington, IN: Phi Delta Kappa Educational Foundation.

Gillis, J. R. (1996, August 2). The study of families needs more-relevant questions. *Chronicle of Higher Education,* p. A40.

Giroux, H. A. (1996). Towards a postmodern pedagogy. In L. Cahoone (Ed.), *From modernism to postmodernism: An anthology.* Cambridge, MA: Blackwell.

Jencks, C. (1991). *The language of post-modern architecture* (6th ed.). New York: Rizzoli. (Original work published 1977)

Mailer, N. (1995). *Portrait of Picasso as a young man.* New York: Atlantic Monthly Press.

Outtz, J. H. (1993). *The demographics of American families.* Washington, DC: Institute for Educational Leadership, Center for Demographic Policy.

Sypher, W. (1978). *Four stages of Renaissance style.* Gloucester, MA: Peter Smith. (Original work published by Doubleday, 1955)

Walling, D. R. (1997). The family myth in the postmodern humanities curriculum. In D. R. Walling (Ed.), *Under construction: The role of the arts and humanities in postmodern schooling* (pp. 217-229). Bloomington, IN: Phi Delta Kappa Educational Foundation.

Wasserstrom, J. N. (1998, September 11). Are you now or have you ever been . . . postmodern? *Chronicle of Higher Education,* pp. B4-B5.

# 4

## CONSTRUCTIVIST TEACHING IN THE VISUAL ARTS

$M$uch of 20th-century teaching has been dominated by a behaviorist model that, in essence, discounts the prior knowledge and knowledge acquisition structures of learners. The various forms of behaviorism share the notion that learning is, in the main, a response by the learner to stimuli present in the environment. This is probably an adequate explanation for the acquisition of simple knowledge, but it fails to account for complex learning. As John Zahorik (1995) puts it,

> Humans do not blindly react to stimuli. They are perceiving, thinking beings with insights, reasoning power, and the ability to make decisions. Humans can and do select the stimuli to which they respond and choose a response that makes sense to them. (p. 10)

This is as true of younger learners as of older ones. And it is particularly important for realizing curriculum and instruction in the visual arts that both shape and are shaped by students' art experiences, knowledge, and understandings. Therefore, in keeping with the metaphor of the blind men and their beast, the portion of the elephant of critical convergence that I take up in this chapter is concerned with instruction. DBAE offers a conceptual framework, postmodernism a way of thinking about the curriculum, and constructivism a philosophical stance that can guide instructional practice.

Writers to whom educators can turn for emerging thoughts on what was initially called *developmental* and later *constructivist* teaching include Lev S. Vygotsky (1978), Jean Piaget (1974), Jerome Bruner (1960), and Howard Gardner (1985).

If educators accept constructivism as a valid approach to structuring teaching, then they also will find compatible notions in complementary philosophies and movements, such as teaching for understanding, Socratic practice, multiple intelligences, and learning styles. All of these also merit at least a nod during the course of this chapter.

## ANTECEDENTS OF CONSTRUCTIVISM

The cognitive theorist Jean Piaget offers a reasonable starting point for discussing, very briefly, the development of constructivist theory. Piaget (1971) suggests that thinking involves two major, complementary cognitive processes: assimilation and accommodation. The first, *assimilation,* is the manipulation of new information gained through experience, which is filtered through an individual's existing understandings or set of knowledge structures, also called a *schema.* Assimilation is the taking in of new knowledge.

The second process, *accommodation,* concerns the altering of existing understandings to accept and act on the new information. Thereby is a new schema constructed. Accommodation literally is the changing of one's mind, a refitting of the knowledge structures.

Robert Slavin (1994) uses these same terms in the following definition: "Constructivism is a view of cognitive development as a process in which children actively build systems of meaning and understandings of reality through their experiences and interactions. . . . Children actively construct knowledge by continually assimilating and accommodating new information" (p. 49). At the heart of constructivist theory are fundamental beliefs about human learning: that humans have a built-in aversion to disorder; that they possess knowledge structures that guide "perception, understanding, and action"; and that learning itself is a matter of strengthening (altering, enlarging, "constructing") those knowledge structures (Zahorik, 1995, pp. 12-13). This implies, to use Jacques Rancière's phrase from *The Ignorant Schoolmaster* (1991), "a confidence in the intellectual capacity of any human being" on the part of educators (p. 14).

At the same time, Zahorik (1995) also reminds us that knowledge itself is a construction, rather than "a set of facts, concepts, or laws waiting to be discovered. It is not something that exists independent of a knower" (p. 11). Thus human knowledge, or understanding (the two terms purposely used as synonyms in this instance), is necessarily conjectural and fallible—subject to change—and so grows through new encounters with information acquired through some form of experience.

Much in the constructivist view of teaching and learning harkens to John Dewey's notions about children as holistic learners. Dewey (1938) opposed the fragmenting of learning into separate—and thus schematically disconnected—subjects because he was convinced that children learn holistically from experiences, which they then organize as new knowledge. Teachers, in Dewey's view, need to be not so much knowledge givers as learning enablers, by which he meant providers of experiential opportunities.

Dewey's concern for experience is particularly pertinent when cast alongside the standards movement, of which I wrote in Chapter 1. I suggested there that a certain modesty in specifying the content standards in art might better serve students and teachers than being too rigid or dogmatic. Maxine Greene (1994) makes the case in even stronger terms when she writes that Dewey, in *Art as Experience* (1934), "took issue with the 'antecedent authoritative standards' by which so many people judged artistic works. He believed that reliance on rules or models of the 'masters' eroded the contribution of art experiences to the enlargement of personal experience" (p. 396). Greene is writing mainly about art production in her reference to "art experiences," but, indeed, the idea that instruction can be limited by being rule bound can apply as readily to, say, art history, in which the "masters" form a centerpiece of study. I turn more specifically to this concern later in this chapter.

In addition to Dewey, other early learning theorists, from Johann Pestalozzi (1746-1827) to Maria Montessori (1870-1952), believed that teaching and learning were most effectively accomplished by finding ways for students to experience new information firsthand and thereby both to assimilate and to accommodate that knowledge. It was, after all, Pestalozzi who commented that the impressions gained through the senses are the foundation of instruction.

## COMPLEMENTARY PHILOSOPHIES

In introducing this chapter, I suggested that some complementary philosophies can assist teachers in thinking about instruction that proceeds from a constructivist platform of understanding. It seems worthwhile, therefore, to take up short discussions of four of these philosophies: teaching for understanding, Socratic practice, multiple intelligences, and learning styles.

*Teaching for Understanding.* Theorists and practitioners writing from a teaching for understanding perspective turn the idea of action around

and focus on student performance—that is, on the creation of action, not simply the participation in or reaction to experience.

When educators speak of teaching for understanding, what they mean by *understanding* (no longer synonymous with *knowledge*) is that a student not only will assimilate new knowledge (take it in and be able to spit it back out) but also will accommodate that knowledge by changing and enlarging the existing schema *to produce action.* Thinking thus moves a step further: Understanding is portrayed by visible performance. David Perkins (1998) comments: "In a phrase, understanding is the ability to think *and act* flexibly with what one knows" (p. 40, italics added).

Effective learning requires both "invisible" activity—thinking, constructing new knowledge and new understandings—and visible activity—demonstrating understanding through some form of action. Perkins (1998) reiterates this point by saying, "In any version of constructivism, a fundamental question is what gets constructed. . . . What the learner acquires is not just a representation but a performance capability" (p. 55). Therefore, in teaching for understanding, it is the teacher's role as a learning enabler to find ways to encourage and assist students to acquire new knowledge; to form new understandings; *and* to demonstrate understanding through actions, or performance.

Grant Wiggins and Jay McTighe (1998) specify performance in terms of "six facets of understanding." If students "truly understand," they (a) can explain, (b) can interpret, (c) can apply, (d) have perspective, (e) can empathize, and (f) have self-knowledge. "These facets," Wiggins and McTighe explain, "are different but related, in the same way that different criteria are used in judging the quality of a performance" (p. 44). But these writers also caution—and this is an important point, particularly with regard to the development of standards—that educators and other readers should "treat these divisions as somewhat artificial and not the only possible take on the subject" (p. 45).

The implications for art production as performance are clear. But what about performance in the disciplines of aesthetics, art history, and art criticism? How might constructivism-based instruction proceed in these areas? As I pointed out in citing Maxine Greene's (1994) concern with art experiences in the previous section, these questions merit a further delving into learning theories that complement constructivist teaching before I take them up in more particular terms.

*Socratic Practice.* The centerpiece of Socratic practice is the Socratic seminar, a conversation focused on a particular idea or text in which the primary role of the teacher is to ask questions. Socratic seminars, ac-

cording to Michael Strong (1997), "improve critical thinking, self-respect, classroom community, initiative, originality, reading, writing, listening, and speaking skills," largely because the approach is structured so that students "learn the ability to learn" (p. 39).

Socratic practice is implicit in what Carl Glickman (1998) refers to as a "pedagogy of democracy." Glickman comments, "It would appear to be just common sense for educators to listen to their students, but the risks of doing so are often perceived as high" (p. 150). He suggests that the teachings of Socrates, the biblical Jesus, and Jean Piaget, among others, share characteristics and exemplify a "teaching culture that stressed interpretation and discussion" (p. 129). All of these teachers, contends Glickman, saw teaching as helping students to initiate their own learning:

> What we can cull from these diverse teachers and cultures is that there is a common essence to the process of learning that transcends ethnicity, race, and culture. It is a pedagogy of democracy, a process that respects the student's own desire to know, to discuss, to solve problems, and to explore individually and with others, rather than to have learning dictated and determined by the teacher. (p. 131)

Socratic practice involves teacher and students wrestling with the making of meaning. The teacher "teaches" by using open-ended questions that encourage and allow students to construct meaning for themselves. This practice contrasts with the use of what Strong (1997) terms "recitation questions, in which the teacher holds the standard of understanding against which the student's response is judged" (p. 15). Similarly, Socratic practice shies away from the common teaching practice of summarizing. In a Socratic seminar on a difficult text, for example, Strong writes that "summarizing what the text 'really means' eliminates opportunities for learning and self-correction" (p. 150).

Socratic practice further illustrates an approach to constructing knowledge and understanding. In Socratic seminars students "perform" (à la teaching for understanding) through discussions in which they explain, interpret, and apply ideas; adopt and adapt perspectives; empathize with various viewpoints; and examine their own knowledge. Socratic practice is therefore a vehicle for social learning and thus is valuable, in particular, in the areas of aesthetics and art criticism, in which meaning and understanding are negotiated.

*Multiple Intelligences.* Howard Gardner, a professor of education at Harvard University, started the brushfire of multiple intelligences that has since swept across the plains of education with *Frames of Mind* (1985). In

that book Gardner set out a theory that humans possess not a single intelligence but one or more "intelligences" related to the manner in which they approach understanding. Initially Gardner defined seven intelligences: verbal/linguistic, logical/mathematical, visual/spatial, body/kinesthetic, musical/rhythmic, interpersonal, and intrapersonal. "Intelligence," said Gardner in a recent interview, "refers to the human ability to solve problems or to make something that is valued in one or more cultures";

> First, though, that ability must meet other criteria: Is there a particular representation in the brain for the ability? Are there populations that are especially good or especially impaired in an intelligence? And, can an evolutionary history of the intelligence be seen in animals other than human beings? (Checkley, 1997, p. 8)

More recently, Gardner has been suggesting an eighth intelligence, "naturalist intelligence" (he cites Charles Darwin as an exemplar), and is exploring a couple of others, spiritual and existential intelligences (Checkley, 1997; Hatch, 1997).

Gardner's theory of process-specific intelligences is one way of explaining how individuals differ in the ways they construct knowledge and understanding. It also is helpful in understanding why teaching art successfully for *all* students means going beyond the visual, art-making aspects. For youngsters with a high degree of visual/spatial intelligence, art making may be the key to art learning. But for students whose primary intelligences are, for instance, verbal/linguistic or interpersonal, the key to constructing art knowledge may be found more readily in aesthetics, art criticism, or art history, where the visual is actively complemented by reading and discussion.

DBAE theorists seek to have students work in the manner of practitioners, to think, for example, as aestheticians think when they study aesthetics. This idea of performance is echoed by Gardner:

> The theory of multiple intelligences wasn't based on school work or tests. Instead, what I did was look at the world and ask, What are the things that people do in the world? . . . What does it mean to be an artist or a sculptor? . . . School matters, but only insofar as it yields something that can be used once students leave school. (Checkley, 1997, pp. 11-12)

*Learning Styles.* Learning styles theorists have had little quarrel with production-focused art education for those students whose learning styles fail to conform to the more restrictive teaching and learning pat-

terns of the traditional (academic) classroom. Rita Dunn (1995), who directs the Center for the Study of Learning and Teaching Styles at St. John's University, points out,

> Certain classroom practices cause many children, particularly boys, real pain. One of these requires that students control their abundant energy and mobility needs and sit still, memorize facts, and answer questions. . . . Another requires auditory memory skills from children who are not biologically able to remember most of what they hear during a 40- or 50-minute lecture or discussion. (p. 7)

Students unable to "make it" in the regular classroom were (and in too many schools continue to be) shunted into classes where hands-on activities predominate: home economics; industrial arts; and, of course, art, which prior to the DBAE movement consisted mostly of studio work.

Echoing, to an extent, Gardner's notions of individualized intelligences, learning styles theorists and practitioners believe that all children can learn, "but each child concentrates, processes, absorbs, and remembers new and difficult information in a different way" (Dunn, 1995, p. 7). Their point is that *every* classroom needs to offer instruction that meets the varied learning styles of the students, including the art classroom, which also should offer art education for students who *are* comfortable with traditional learning patterns.

A mirror concern can be seen in some core academics. For example, when the writing process movement was picking up instructional steam in the mid-1980s, there was some danger that "*the* writing process" might become yet another formula, a set of rigid steps that all teachers and students were expected to take to produce good writing. These steps included prewriting, drafting, editing, and so on. At the time I suggested,

> Two misconceptions that are most detrimental to teaching writing effectively are 1) writing is a deliberate, linear process, and 2) therefore, it is essential for teachers to teach students to write in a deliberate, linear fashion. The first notion is true of only *some* writing produced by *some* writers. It is certainly not true of all writing or of all writers, maybe not even most writing or most writers. Consequently, no foundation exists for the second notion. (Walling, 1987, p. 7)

About the same time the syndicated columnist William F. Buckley Jr. (1986) wrote an essay complaining about being criticized for writing

"fast," by which his critics meant that he was skipping some of the "steps." Buckley countered with some historical examples:

- The British novelist Anthony Trollope held to a personal goal of writing 250 words every 15 minutes to reach his daily quota of 3,500 words.
- The fictional lawyer Perry Mason's creator, Erle Stanley Gardner, dictated nonstop to a staff of secretaries, working on several projects at the same time.
- The 19th-century politician John C. Calhoun composed his speeches while plowing his fields, "writing" in his mind and later simply transcribing the speeches on paper.

Buckley's point—and mine and Dunn's—is that there is no one right way to go about learning. Everyone—students as well as adult writers and artists—learns and performs individualistically.

Dunn and others also expand Gardner's multiple intelligences theory by noting that learning styles vary within the intelligences. Dunn cites a study in which she participated (Milgram, Dunn, & Price, 1993), involving adolescents in nine culturally diverse nations, that showed that "within the same intelligence areas, the learning styles of gifted students tended to be essentially similar—and significantly different from the learning styles of underachievers" (Dunn, 1995, p. 27).

## A PRACTICAL EXAMPLE

It may be easiest to see how constructivist theory can be used to inform instruction by sketching an example, which I also use to tie in, preliminarily, the convergent themes of the preceding chapters: standards, DBAE, and postmodernism. I refer to this example as preliminary because I will introduce yet another theme of critical convergence—technology—in Chapter 5 and then use Chapter 6 to summarize the thematic connections of this entire book.

Let us suppose that a high school art teacher wishes to take up the process theme of sgraffito. For the uninitiated, *sgraffito* is an Italian word, literally meaning "scratched," that refers to the graphic technique of scratching through a surface to reveal what lies below it.[1] Often the scratched design reveals one or more colors that lie below the top layer of color, as in pottery. A ceramic piece of one color is coated with clay slip of another color, and a design is created by scratching or

carving through the slip coat. But this use is only one of many to which sgraffito can be, and has been, put.

Let us further suppose that the teacher has chosen this topic to address an aspect of the arts standard that focuses on the student being able to "understand and apply media, techniques, and processes related to the visual arts" (Consortium of National Arts Education Associations, 1994). Clearly, the sgraffito technique can be taught through art making. For example, the students might explore making clay pots, coating them with slip of a different color, and then scratching designs into them before firing. Or they might simply take clays of different colors, roll each clay into a sheet, and then layer the sheets two or three deep. Having made this clay "sandwich," they then carve and scratch designs, exploring both color composition and relief in more detail than might be obtained on a ceramic piece.

Yet another technique might be to instruct students to develop a plaster sgraffito composition. First, students draw designs to the actual size of a disposable aluminum cake pan. The designs emphasize shape rather than line and are limited to two or three colors. Next, the students pour layers of colored plaster into the pan to match the colors they have chosen for their designs. Finally, using home-made clay loops, linoleum cutting tools, and other carving instruments, the students cut their designs into the damp plaster.

These art-making activities directly address the process standard, and they will match some students' visual/spatial (or bodily/kinesthetic) intelligence and active learning style. But this aspect is merely a starting point for the teacher interested in reifying the abstract notions of the standards, DBAE theory, themes of postmodernism, and constructivist teaching.

At some point in this unit on sgraffito, students also might begin to look at the process from a historical/cultural perspective. They can discover for themselves, using fairly general reference sources, that the sgraffito seen on modern ceramics employs essentially the same process that was used for the famous stoneware from China's Tz'u Chou region during the Sung period (960-1260 C.E.).

Moreover, they will find that sgraffito has not been confined to pottery. It also has been used as architectural decoration. This point will lead them to the Renaissance technique of brushing lime wash over a mortar colored with soot. Engravings by well-known artists during the Renaissance often were replicated to resemble gigantic pen-and-ink drawings on the sides of buildings. Examples of this type of sgraffito still can be found today in the Bohemia region of the Czech Republic. Another architectural variation with roots in the Renaissance is the use

of pigmented plasters—similar to the miniature, aluminum-pan version above—and the large-scale use of colorful, relief designs, comparable to murals, which can be seen on modern buildings in Germany and elsewhere in Europe.

As students discover and consider this history, they may take up related themes: How has the sgraffito technique changed over time? How have various cultures and periods interpreted the use of sgraffito? What characteristics of design are most successful for the various forms of sgraffito? These questions respond to the postmodern themes of pluralism (or multiculturalism) and universality—"sgraffito across centuries and cultures"—but also to the themes of particularity and difference—"culture-specific sgraffito." Questions of this sort also awaken students' interests in aspects of art history, art criticism, and aesthetics.

For the high school students in this example, the teacher also might initiate a discussion—à la the Socratic seminar—on an aesthetic question, for instance, of High Art versus Low Art. For those who distinguish High and Low, where does sgraffito fit? If architecture is High Art and pottery is Low Art, is sgraffito on buildings High Art, whereas sgraffito on pottery is Low Art? Does complexity matter? Is bigger "better"?

One reason why I chose sgraffito for this example is that it is not a well-known technique, except perhaps in the field of ceramics, where it is fairly common. The relative "novelty" of sgraffito, if you will, is a strength in that its study can encourage students to construct new knowledge and understandings absent a canon of masterworks. I suggested earlier in this chapter that instruction can be limited by being rule bound, which happens most easily when the subject or technique is well known, when there are "masterpieces" that virtually everyone knows. Sgraffito has examples but not necessarily exemplars. Thus it sidesteps this potential limitation.

## FAMILIARITY BREEDS . . . PRESUMPTION

This last point, sidestepping potential limitation, is worth exploring because it gets to the heart of constructivist theory, that knowledge is constructed on a scaffold of existing understanding. The proverbial phrase is, "Familiarity breeds contempt," which indeed may be the case. To know often is to dismiss. But the dismissal of the familiar from active investigation more often stems not from disdain but from presumption. If a work of art is familiar, students (and teachers) often presume that they know more about the work than they do. This prior "knowledge" often needs to be set aside to construct new knowledge and understanding.

The use of sgraffito is helpful in this regard because few students will have much prior knowledge of this art technique or its various representations. But what about familiar works: Picasso's *Guernica* or *Les Demoiselles d'Avignon*, Michelangelo's *David*? Constructivist theory is most exercised when students are moved to go beyond the familiar that is so easily dismissed or overlooked.

Catharine Stimpson and Brenda Wineapple (1999) take up this problem in a whimsically titled piece, "An Icon Is an Icon Is a Challenge to Teach," which, appropriately, is about teaching the literary works of Gertrude Stein. They point out that Stein is an icon: "Two-dimensional, larger than life, and smacking of celebrity, icons command instant attention, even a kind of reverence. But icons pose problems for us in academe. It is extraordinarily difficult to teach and to write about them" (p. B6). "To study icons," Stimpson and Wineapple aver, "requires dislodging the reflexive, stock assumptions associated with them, and restoring them to the circumstances of the world that gave birth to them—a world of chance and time, of place and person, of vulnerability and contradiction" (p. B6).

The icons of art, like the icons of literature, require no less. *Guernica*, by Gertrude Stein's friend Pablo Picasso, cannot be shrugged off as a modernist representation of the horrors of war. That is merely the iconic identification. Behind the image is a history in which Picasso, not much affected by World War I because he was a citizen of a neutral county, was later stirred to great passion when his native Spain erupted in civil war in 1936. The iconic *Guernica* is about war; the real painting is about Picasso's war.

Similarly, there is a history behind *Les Demoiselles d'Avignon*, painted three decades earlier. Students are likely to dismiss the painting as representative merely of Picasso's initial adoption of African forms. But, in fact, this painting began as a brothel scene (Avignon here is not the town but Avignon Street in a notorious district of Barcelona) and only later incorporated the aesthetics of African and Oceanic sculpture in which Gauguin and the Fauves had taken the lead. How the work began was not how it ended, because during the painting of *Les Demoiselles* Picasso visited the old Ethnological Museum in the Palace of the Trocadéro. Only then did the African mask aesthetic that had affected Gauguin and others strike Picasso full force, such that he brought it home to his studio. In later years he would tell André Malraux,

> The masks weren't just like any other pieces of sculpture. Not at all. They were magic things. . . . I understood what the Negroes used their sculpture for. . . . They were weapons. To help people avoid coming under the influ-

ence of spirits again, to help them become independent. They're tools. If we give spirits form, we become independent. (Malraux, 1974/1976, pp. 10-11)

This was a real moment in Picasso's "world of chance and time, of place and person" (Stimpson & Wineapple, 1999, p. B6).

Art history, art criticism, and aesthetics are likewise tools—tools for the art teacher to help students construct new understandings of familiar "masterpieces," icons of art. Much in Picasso's body of work provides for comparisons, for building a knowledge of how the artist worked, what inspired him, what excited his aesthetic energy. In similar fashion, comparison across cultural aesthetics can help students move toward active construction of knowledge and understanding, particularly of works that have become too familiar. Michelangelo's *David* offers an example.

"The" *David* has become the iconic representation of the biblical figure, indeed less associated with the Bible story than with "maleness" itself. But, in fact, even in the cultural aesthetic of the Italian Renaissance, Michelangelo's *David* (1501-1504) does not stand alone. To get beyond (or behind) the iconic *David*, teachers might introduce students to the Early Renaissance *David* (1430-1432) by Donatello, who portrays the slayer of Goliath as a willowy youth, far different from the broad-shouldered man with the furrowed brow that Michelangelo saw staring back at him from the marble. Yet Donatello's bronze is every bit as significant as Michelangelo's sculpture, because it was the first freestanding life-size nude statue to be created since antiquity and thus a marker for the start of the Renaissance.

Chronologically opposite Donatello comes the *David* (1623) of Gian Lorenzo Bernini during the Baroque period. Unlike Michelangelo's almost stoic *David*, Bernini's *David* is contorted in the act of cocking his slingshot, body twisted to gain momentum, just before he hurls the stone. His mouth is set in concentration, his lips are pulled in, and his brow is fierce.

These three representations of David offer windows into each artist's vision of how David should be represented but, even more so, how the human figure should be represented according to the aesthetic values of the sculptor's time and culture *and* his or her personal sensibilities. How did Donatello envision David? Why did Bernini choose to portray David not at rest (as Michelangelo saw him), but as a figure of potent fury? (H. W. Janson, 1962, commented, "If we stand directly in front of this formidable fighter, our first impulse is to get out of the line of fire" [p. 410].)

Stimpson and Wineapple (1999) comment that students "typically prefer the icon to the text. In teaching Stein, we have to explore with our students some of their basic premises about language" (p. B7). In the same manner, teachers of art must help students to look beyond the iconic *Guernica*, the iconic *David*, and to discover, in so doing, a wealth of knowledge about artists' techniques, inspirations, and sensibilities.

## REFINING THE MODEL

How can a teacher know what a student has learned? This assessment question is at the heart of constructivist teaching. What knowledge and understanding has the student constructed as a consequence of instruction and experience? I would contend that this also is a different question from, did the student learn the prescribed knowledge? Or does the student now understand in the manner that I (or the curriculum) have set up as ideal (or "satisfactory" or "competent")?

Let us take up this latter issue first. Much in the debate over how student achievement should be assessed in relation to standards, whether national or localized, harkens to the four points of Tyler's (1949) famous rationale:

1. What educational purposes should the schools seek to attain?
2. What educational experiences can be provided that are likely to attain these purposes?
3. How can these educational experiences be effectively organized?
4. How can we determine whether these purposes are being attained? (p. 1)

I echoed Tyler's questions in Chapter 1 when I suggested that educators need to consider *universals, the community,* and *the individual* in determining what knowledge and understanding are of most worth.

Many education theorists (and others, such as Stephen Covey in *Seven Habits of Highly Effective People*) aver that it is essential to teach with an end in mind—that is, to define an objective, a standard, and then to design instruction so that the student will reach that end, will construct *that* knowledge. Grant Wiggins and Jay McTighe (1998) use the phrase "backward design" to connote an approach to curriculum and instruction that begins with consideration of "results," the goals or standards to be met, but this is not, in fact, an unusual approach.

Wiggins and McTighe (1998) offer three sequential steps for their "backward design" process: first, identifying results; second, determining evidence; and, third, planning experiences and instruction (pp. 9-13)—almost the Tyler (1949) rationale written in reverse order. And the application of this process can be relatively straightforward (or straight backward?). One can begin, for example, with the national goals, "localized" in some manner (specified by the state or local district, determined by the school or department), and, with those more specific objectives in mind, define the manner in which students can demonstrate competence. The manner of assessment—how the teacher identifies student competence, how the student demonstrates competence—can range from simple observation (teacher informally sees student performing competently) to direct performance (student formally performs with competence). It can consist of direct interaction (conversation, questions and answers) or indirect interaction (quizzes, tests). All of these are useful assessment methods and, indeed, a mix of various types of assessment is preferable to the use of only one or two. A mix, after all, is less likely to put some students at an advantage and others at a disadvantage because of learning style or intelligence differences.

Localizing standards is a necessary component of assessment that is ends driven. Teachers must have in mind some goals that are measurable and then design instruction that will move students toward the achievement of those goals. This is a highly useful way of thinking about instruction, but this approach also has limitations and, I would argue, should not be used exclusively. In the visual arts, open-ended exploration and experimentation—true "creativity"—are valid ends as well. This is the other thinking point with regard to constructivist teaching, and it has ramifications for how assessment is viewed.

In the Socratic seminar a real goal for students is total engagement in the search for meaning and the construction of knowledge. The teacher does not ask questions to which he or she already knows the answer. Rather the teacher asks questions to involve students in creating meaning for themselves and, in so doing, in learning how to learn (Strong, 1997, p. 39). Maxine Greene (1994), in addressing national standards issues, writes,

> I would like students and their teachers to become conscious of the need for transformative, risk-taking, higher-order thinking. . . . I want to see people resonate to the kind of knowing that plunges them deeply to central ideas and complex understandings; I want them to feel connections between what they are coming to know and the contexts of their lives or

their lived worlds. I want to provoke dialogue and eager transactions in the classroom, whether they have to do with works of art or with art-making and perceiving. (p. 398)

One hopes that given sufficient freedom and provocation students might come to assert, as Picasso is reputed to have said, *"Je ne cherche pas; je trouve"* ("I do not search, I find"). Greene (1994) suggests, "If there are to be standards or frameworks, I would like to see them emerge from the class itself—spelled out in the light of what is valued and what can be incarnated individually as principle" (p. 398).

This open-ended, "transformative" approach to constructivist teaching requires an equally open-minded approach to assessment questions. And, indeed, educators will need to consider carefully how a balance can be struck between the need to define clear standards in advance of instruction and the need for standards to emerge as a result of constructing new knowledge and understanding.

Orchestrating instruction is a complex challenge, and it is difficult at times for teachers to step back, to relinquish the directorial role for a facilitative one. I also am reminded of what the great conductor Zubin Mehta once said in a television interview: "The secret of conducting is knowing when not to conduct, when to get out of the musicians' way."

## NOTE

1. Sgraffito became a personal interest when I was teaching in Germany during the early 1980s and led to writing the article that I have used to refresh my memory on this topic (Walling, 1986).

## REFERENCES

Bruner, J. (1960). *The process of education.* New York: Vintage Books.

Buckley, W. F., Jr. (1986, February 9). With all deliberate speed: What's so bad about writing fast? *New York Times Book Review,* p. 3.

Checkley, K. (1997, September). The first seven . . . and the eighth: A conversation with Howard Gardner. *Educational Leadership,* pp. 8-13.

Consortium of National Arts Education Associations. (1994). *National standards for arts education: What every young American should know and be able to do in the arts.* Reston, VA: Music Educators National Conference.

Dewey, J. (1934). *Art as experience.* New York: Minton, Balch, & Company.

Dewey, J. (1938). *Experience and education.* New York: Macmillan.

Dunn, R. (1995). *Strategies for educating diverse learners* (Fastback 384). Bloomington, IN: Phi Delta Kappa Educational Foundation.

Gardner, H. (1985). *Frames of mind.* New York: Basic Books.

Glickman, C. D. (1998). *Revolutionizing America's schools.* San Francisco: Jossey-Bass.

Greene, M. (1994). The arts and national standards. *The Educational Forum, 58* (Summer), 391-400.

Hatch, T. (1997, March). Getting specific about multiple intelligences. *Educational Leadership,* pp. 26-29.

Janson, H. W. (1962). *History of art.* Englewood Cliffs, NJ: Prentice Hall; New York: Harry N. Abrams.

Malraux, A. (1976). *Picasso's mask* (J. Guicharnaud & J. Guicharnaud, Trans.). New York: Holt, Rinehart & Winston. (Original work published as *La tête d'obsidienne.* Paris: Gallimard, 1974)

Milgram, R. M., Dunn, R., & Price, G. E. (Eds.). (1993). *Teaching and counseling gifted and talented adolescents for learning style: An international perspective.* Westport, CT: Praeger.

Perkins, D. (1998). What is understanding? In M. Stone (Ed.), *Teaching for understanding.* San Francisco: Jossey-Bass.

Piaget, J. (1971). *Genetic epistemology.* New York: Norton.

Piaget, J. (1974). *To understand is to invent: The future of education.* New York: Viking.

Rancière, J. (1991). *The ignorant schoolmaster: Five lessons in intellectual emancipation* (K. Ross, Trans.). Stanford, CA: Stanford University Press.

Slavin, R. (1994). *Educational psychology: Theory and practice* (5th ed.). Boston: Allyn & Bacon.

Stimpson, C. S., & Wineapple, B. (1999, January 22). An icon is an icon is a challenge to teach. *Chronicle of Higher Education,* pp. B6-B7.

Strong, M. (1997). *The habit of thought.* Chapel Hill, NC: New View.

Tyler, R. W. (1949). *Basic principles of curriculum and instruction.* Chicago: University of Chicago Press.

Vygotsky, L. S. (1978). *Mind in society.* Cambridge, MA: Harvard University Press.

Walling, D. R. (1986, January). Sgraffito. *School Arts,* pp. 18-20.

Walling, D. R. (1987). *A model for teaching writing: Process and product* (Fastback 256). Bloomington, IN: Phi Delta Kappa Educational Foundation.

Wiggins, G., & McTighe, J. (1998). *Understanding by design.* Alexandria, VA: Association for Supervision and Curriculum Development.

Zahorik, J. (1995) *Constructivist teaching* (Fastback 390). Bloomington, IN: Phi Delta Kappa Educational Foundation.

# 5

# THE TECHNOLOGICAL RENAISSANCE IN ART EDUCATION

The fifth and last piece of this elephant of critical convergence is technology or, more specifically, computer technology and how various forms of this technology can be used in art education. Thus far, we have moved successively through ways of rethinking art education, beginning with *goals and standards* in Chapter 1, a *conceptual framework* in the discussion of DBAE theory in Chapter 2, *curriculum* as conceptualized in postmodern terms in Chapter 3, and *instruction* from a constructivist teaching point of view in Chapter 4. Technology offers what might be termed *enrichment*. Not all classrooms—certainly not all art classrooms—are "wired," but those that are computer capable can offer students unparalleled opportunities to enlarge and enrich their experience of the visual arts. As more and more classrooms become wired, computer technology will become a standard feature of education in all disciplines. But, for now, most such technology must remain in the limbo of "enrichment."

*Renaissance* means "rebirth" or "revival." So how, one might ask, can I refer to a "technological renaissance" in the title of this chapter? Isn't technology new? The simple answer is no. *Computer* technology is new, but technology itself, as a critical factor in art and art education, is not new. Take perspective, for example.

A principal technology in the critical convergence of ideas that produced the Renaissance, perspective is conventionally defined as the

technique of representing three-dimensional objects and depth rela-
tionships on a two-dimensional plane. The invention of linear perspec-
tive is credited to Filippo Brunelleschi (1377-1446), whose main occupa-
tion was architecture. His claim to distinction rests not only on his
design for the dome of the cathedral of Florence and the Pitti Palace but
also on other structures, such as the sacristy of the church of San Lo-
renzo, also in Florence. In that church Brunelleschi captures a classical
regularity that represents a radical departure from the conventions of
Gothic architecture, then the prevailing mode. In fact, the church is "a
particularly clear and convincing demonstration of scientific perspec-
tive" (Janson, 1962, p. 319).

What began, arguably, with Brunelleschi found echoes, extrapola-
tions, and innovations in the work of others, such as Leon Battista Al-
berti (1404-1472), another artist and architect (a contributor to the de-
sign for Saint Peter's in Rome), whose treatises on painting, sculpture,
and architecture influenced many Renaissance artists, architects, sculp-
tors, and even scientists. (His treatise, *On Painting*, published in 1435, is
dedicated to Brunelleschi.)

It must be remembered that during the Renaissance the arts and the
sciences were not yet viewed as separate disciplines, unlike in modern
times, when they have been isolated from one another by a seemingly
unbridgeable chasm. (Some efforts of postmodernism have begun to
build bridges, but they are limited still.) Albrecht Dürer (1471-1528), the
artist who epitomizes the German Renaissance, devoted his last years
to art theory, including a treatise on geometry (1525) in which he drew
on a thorough study of Piero della Francesca's discourse on perspec-
tive. Piero della Francesca (1420?-1492) is probably best known for his
fresco cycle, *Legend of the True Cross*, which demonstrates his mastery of
geometric perspective.

The notions of perspective that most casual observers take for
granted today shaped, as much as were shaped by, "optical science"
during the early Renaissance. In fact, as Wylie Sypher (1955/1978)
points out, "There are many different kinds of perspective operating at
once in renaissance styles, in painting, sculpture, and even architec-
ture":

Ordinarily we think of perspective as optical or "vanishing-point" per-
spective, an arrangement of objects within cubical space so that each ob-
ject is clearly "located" in relation to the enclosing space and to other ob-
jects by a system of co-ordinated lines ("orthogonals") converging in a

"visual pyramid" toward an exact focal point situated upon an implied or defined horizon. This sort of mathematical perspective—as artificial as any system of vision ever invented—became an orthodox mode of representing space in renaissance painting. (p. 27)

"But," Sypher continues,

throughout the renaissance, painters, consciously or not, were actually using quite other codes of perspective, relating figures to scene in quite other ways. Inevitably a "surface" perspective, in breadth—a horizontal or shallow perspective—was always tending to counteract "deep" perspective, thus creating a tension between seeing in planes and seeing in funnel-like recession. Then, too, a conceptual or hierarchical perspective, essentially medieval, persists curiously in Botticelli and mannerist painters like Parmigianino. . . . Atmospheric perspective, in the evolution of which Leonardo [da Vinci] played so large a role, locates figures in space by immersing the more distant ones in a "blue" vagueness. . . . Perspective need not be single; it may be "double" whenever the painted scene is a place of intersection for two or more systems of perspective. (pp. 27-28)

Sypher goes on for several paragraphs of explanation about various types of perspective, but this excerpt is sufficient to suggest the complexity of this Renaissance technology that is now taken largely for granted in representational art. Most students today, in fact, develop a sense of perspective whether they study it formally or not, because its pervasive influence on Renaissance art profoundly reshaped how everyone would see the world from then on.

Technology during the Renaissance was not limited to perspective, of course. Leonardo da Vinci was as good an inventor and engineer as he was a painter. Michelangelo was as able an architect and painter as he was a sculptor. And Dürer's inventions and anatomical investigations in the 1500s readily follow the standard set by Leonardo half a century earlier. Artists of the 15th and 16th centuries were likely also to be architects, engineers, inventors, anatomists, and metallurgists who moved fluidly between scientific and artistic pursuits, before, as James Bailey (1998) puts it, "the printing press drove a five-hundred-year wedge between science and art" (p. 17).

My point in reviewing this history is simple: Technology that we take for granted today was new in the 15th century, and that new technology, such as perspective, was critical, along with other factors, in the convergence of ideas that shaped the new paradigm of the Renaissance. Computer technology today, which is new and which we do not yet take for

granted, is positioned in the same way. Computer technology, along with other factors, is shaping the new paradigm of the Information Age.

## COMPUTER TECHNOLOGY AND
## THE PACE OF CHANGE

I have drawn comparisons (such as the preceding one) between the critical convergence outlined in this book and the critical convergence of the Italian Renaissance merely to assist the reader in understanding the power of such convergence, not to suggest any great similarity between the world of 1500 and the world of 2000. The two ages are distinct. Our own age is likely to be seen 500 years from now as far more dynamic, certainly within a shorter span of time.

Moreover, the Renaissance, having originated in Italy, spread northward through Europe. But it did not go much farther, at least not during the most critical and dynamic period of 1400 to 1600. In this respect the Renaissance period and our own time are enormously different from one another. Marilyn Ferguson (1980) observed, "Not even the Renaissance has promised such radical renewal; as we have seen, we are linked by our travels and technology, increasingly aware of each other, open to each other" (p. 406).

Much of this dynamic change is a result of the rapid pace of change, a far more rapid pace than was possible in the Renaissance. Christopher Evans, in his landmark book, *The Micro Millennium* (1979), offered a now-famous illustration:

> I keep emphasizing how dramatically things have changed; this is necessary because the scale of change is so enormous that it is easy to underestimate it. A useful analogy can be made with motor cars to put things in perspective. . . . Suppose for a moment that the automobile industry had developed at the same rate as computers and over the same period: how much cheaper and more efficient would the current models be? If you have not already heard the analogy the answer is shattering. Today you would be able to buy a Rolls-Royce for $2.75, it would do three million miles to the gallon, and it would deliver enough power to drive the *Queen Elizabeth II*. And if you were interested in miniaturization, you could place half a dozen of them on a pinhead. (p. 76)

Complementing this rapid pace is the global effect of computer technology. It is far easier to describe the few places untouched by such technology than the other way around. And there are fewer and fewer such

places every day. The 21st century "renaissance" is a universal phenomenon. Commentators across the century have described various modes of transportation as "shrinking" our globe—first ocean-going vessels and then the train, the automobile, the airplane. But the computer is the real globe shrinker.

In the Information Age information is currency. The computer-linked information highway knows no boundaries, neither national borders nor oceans. Sitting comfortably in my den, I can bring the world's information into my home at the touch of a finger. My computer screen will allow me to visit the Smithsonian one minute and the Louvre the next, something that not even the fastest airplane will ever be able to do. If information is the gold of the Information Age, then the computer is each user's personal treasure chest. Moreover, it is a treasure chest for the art educator.

## COMPUTER TECHNOLOGY AND ART MAKING

It will be easiest, I believe, to organize a discussion of computer technology around two themes: using the computer to create and to manipulate images and using the computer to investigate the visual arts. The first involves art making, whereas the second involves art history, art criticism, and aesthetics, to use the component disciplines of DBAE theory.

Students and mature artists alike are investigating new ways to use computer technology in art making. A couple of examples may be helpful.

Brenda Grannan is a Cincinnati-based illustrator whose work has been published in numerous magazines and books. She creates her artworks almost entirely by using a computer. She begins a typical book or magazine illustration by drawing a basic sketch, which she electronically scans onto a computer disk. This image is then manipulated and finished using *Adobe Photoshop,* a computer program that allows her to alter, add, and remove lines; create layers of texture; and wash in areas of color. The result is a richly complex image that can go from Grannan's disk directly to the printed page. No finished, "frameable" work is produced—or necessary.

This a major change from the traditional way of doing commercial illustration, in which a finished work on paper or illustration board would be submitted to a magazine editor. The traditional, finished image was largely "set" and not subject to much alteration. By contrast, Grannan's "finished" image can be further manipulated to suit her

client's wishes: Pictorial elements can be moved, added, or eliminated; colors and textures can be changed. Such "postproduct" manipulation is virtually impossible with traditional media—except that today, subject to some limitations, a finished work that is scanned onto a computer disk also can be manipulated to a degree. The amount of malleability introduced by Grannan, however, is greater.

Christopher Ganz approaches computer technology differently. As of this writing, Ganz is a graduate student working on a master of fine arts degree in printmaking. He also works in drawing and painting, using various media. His goal is to produce a finished, traditional artwork—a frameable piece, in other words. On the way from sketch to finished work, however, Ganz often scans his work onto a computer disk and uses *Adobe Photoshop* or a similar program to alter the image, to try out versions of the image or the idea, which he then prints out and uses as a basis for further refinement of the image that will be rendered traditionally. Ganz uses the computer as a composing tool to explore scale, composition, and perspective. Often he also lays in color on the computer to get a sense of direction for the next stage, when he will take the image in hand again.

Ganz also has experimented with manipulating scanned images that he has drawn and using the computer to output mylar prints, often as color separations, which are used in photo-silk screen work.

Both of these artists are comfortable with the computer graphics program called *Adobe Photoshop*, one of the most popular available. But a number of other similar programs can be found, including others in the Adobe line, such as *Adobe Illustrator, Adobe GraphicStudio,* and *Adobe Photodeluxe.* A useful *Photoshop* guide is Nolan and LeWinter's *Fine Art Photoshop* (1998). Many guides to *Photoshop* and other graphics programs can be found in libraries and bookstores. As computers become more commonplace in schools, students in art classes also will need to have greater access to graphics programs—if they are to work in the manner of professional artists.

I would also point out that a number of "art" programs are available for young children. These programs can be found on disk, on CD-ROM, and online, but most involve simply arranging set elements, such as stock figures, objects, backgrounds, and so on. With some programs, children can add animation, sounds, music, and voices. Although these programs often are fun to use, they are the creative equivalent of the coloring book and not suitable to meaningful art education.

As a last example of art making using computer technology, an interesting interdisciplinary project has been described as "virtual dance." A virtual dance was commissioned by the Cooper Union for the

Advancement of Science and Art, in which the dancer and choreographer Bill T. Jones

> allowed his movements to be recorded using a process in which special cameras tracked the paths of two dozen reflectors attached to his body. The movements were then manipulated electronically and re-choreographed on a computer screen to make an original virtual performance. (Ingalls, 1999, p. A29)

As a result, dance and drawing were intermingled: "The abstract dancers looked like animated charcoal drawings, displaying all of the compelling spontaneity of that medium" (p. A29).

Little imagination is needed to envision countless art-making projects in which connections can be made between traditional media and computer technology.

## COMPUTERS AND AESTHETICS, ART HISTORY, AND ART CRITICISM

Two forms of computer technology offer resources for art educators that can meet their needs in the areas of aesthetics, art history, and art criticism. The first are disk-based and CD-ROM resources, many of which replicate but often enhance print resources. The second involves connectivity between a computer in a classroom, a computer laboratory, or a home and the Internet, often termed the "information highway."

Disk-based resources are rapidly being replaced by resources on CD-ROM because of the large memory capacity of the latter. CD versions of resource books, from encyclopedias to art collections, offer students and teachers a wealth of information. Often these CDs also include sound clips and video clips, such as film footage of historic events, snippets of famous speeches, and so on. These "extras," not available in standard print resources, enliven and enlarge the resources, such that students do not merely read the information, but experience it. Most CD-ROM resources also include a search program as a standard feature, which allows the user to locate information rapidly and to navigate from one area (or "page") to another with ease.

Although CDs cannot replace the many books that provide useful, in-depth information about art history, frequently they offer highly accessible basic information and excellent starting points for study. Most students also find CD-ROM resources motivating, because they

are interactive and because computer technology in itself is seen as engaging. Examples of affordable CDs that schools will find useful include *The Complete National Geographic*, 109 years—every article and photograph—of *National Geographic* magazine (searchable and printable) on 31 CDs (priced at less than $200); *World Book Multimedia Encyclopedia* (1999) on 2 CDs (about $40); and *Encyclopaedia Britannica CD* (1999), all 32 print volumes on CD-ROM with question-and-answer interactivity (about $80). The list of general reference CDs is almost endless. These three examples were found in a single issue of a mail order catalog for Macintosh-based computers called *MacConnection*, available in print or accessible online (http://www.macconnection.com). PC-based programs similarly abound.

Art images and history in CD-ROM form can be used to expand classroom discussion into the areas of art criticism and aesthetics; little is available directly related to these disciplines in CD-ROM form, however. For more specialized topics, the better electronic source is the Internet, which is the second form I mentioned earlier.

The number of schools with access to the Internet is increasing rapidly. From only 33% of schools in 1994, Internet access was extended to 78% of schools by 1997 (National Center for Education Statistics, 1998). And it seems clear that the Clinton administration's goal of connecting all schools to the Internet by the beginning to the new millennium will be reached. As that connectivity takes place and is extended into more individual classrooms, art educators in particular will find the information highway to be an invaluable resource.[1]

A key portion of the Internet that will be highly valuable in the context of art history, art criticism, and aesthetics is the World Wide Web, denoted by the *www* at the beginning of the URL (Universal Resource Locator), or Internet "address." A growing number of museums, galleries, archives, and libraries maintain websites; and these websites are continually being updated and expanded. They contain images of artworks, reference collections, online texts, and other information that can vastly expand the instructional reach of teachers. Many also include lesson plans and sample lessons to make a teacher's work even easier.

There are so many websites that it may take a considerable amount of time to search out those of most value. Three starting points worth mentioning are World Wide Arts Resources (http://www.wwar.com), which features more than 500 types of resources and provides links to nearly 1,000 websites worldwide of museums, indexes, galleries, art schools, children's resources, and more; World Wide Web Virtual Library, the museum pages (http://www.icom.org/vlmp), which are focused

on art museums and other historical collections; and LibrarySpot (http://www.libraryspot.com), which serves as a gateway to the websites of more than 2,500 libraries around the world.

Following are three examples that show how art teachers and students might use Internet access to enhance instruction and learning. The first demonstrates how using the Internet can help a teacher to capitalize on a teachable moment. The second shows how to plan a "virtual field trip." And the third demonstrates how the Internet can facilitate art research.

## SERENDIPITOUS TEACHING AND LEARNING

The facility with which one can use the World Wide Web and the wealth of resources to be found there make the Internet an ideal vehicle for serendipitous teaching and learning, for capitalizing on a teachable moment. For example, not long ago I read a small notice in *Art News* that the Italian government had rejected a request from the National Gallery of Art in Washington, D.C., to bring the Bernini *David* to the United States. The sculpture would have been the centerpiece of the gallery's celebration of the 400th anniversary of Bernini's birth. The Italian authorities had deemed the six-foot marble figure too fragile to travel.

Now, of course, most students would not have been able to travel to Washington to see Bernini's famous sculpture of the biblical David in any case. Far fewer would be likely to travel to Rome's Borghese Gallery to see the sculpture there. Apart from books, how might students discover (or be led to discover) more about the *David* and its creator, the Renaissance artist Gian Lorenzo Bernini (1598-1680)? I decided to search the Internet.

Scarcely had my fingers touched the keyboard than I found disheartening news. Although hundreds of museums maintain websites, sadly, the Borghese Gallery, where the Bernini *David* stands, was not among them. (Italian museums in general are electronically "behind the curve" among European museums.) And so I began to look for other possibilities.

I accessed the World Wide Web Virtual Library museum pages and World Wide Arts Resources. Both gave me the same bad news about the Borghese Gallery, but both also led me to other sites. For example, I found the website of the Uffizi Gallery in Florence (http://www.uffizi.firenze.it), which contained other examples of Bernini's work. (The site can be explored in English as well as Italian.) I found more Bernini sculptures at Mark Harden's texas.net Museum of

Art (http://lonestar.texas.net/~mharden/archive/ftptoc/bernini_ext. html)— but no *David*.

Because Bernini also was an architect, several sites offered information on that aspect of his career. For example, Professor C. W. Westfall's Architectural History 102: Renaissance and Baroque Architecture (http://www.lib.virginia.edu) provided pictorial tours of Bernini's San Andrea at Quirile (1658-1670), Piazza San Pietro (1655-1667), and the artist's contributions to the long architectural history of the Palais du Louvre (1664). This last structure sparked my interest and made for a fascinating side trip to the website of the Louvre Museum in Paris (http://www.louvre.fr). That website is extensive and provides virtual tours of the museum—the palace itself and the galleries—in several languages. In fact, if I had wanted to look at architecture in general, I could have found a wealth of information at the Great Buildings Collection website (http://www.greatbuildings.com), which catalogs well-known architecture worldwide and offers a searchable database.

Finally, I landed at the website that was the most valuable of my wanderings: *Thais—1200 anni di scultura italiana,* or 1200 Years of Italian Sculpture (http://www.thais.it). Not only did this site contain numerous examples of Bernini's sculptures but, most important, it contained the *David*. The famous statue was shown in both a full view and a close-up of the head. Were I developing this topic for the classroom, I might choose to project these views for my students to study. In fact, a real-time projection could be created using a minimum of equipment to display a life-size view of the *David* in the classroom as it was displayed on the computer monitor. LCD projectors that interface with computers to display large-scale images range from under $2,000 to more than $11,000. But prices are coming down, and the LCD projectors are no more difficult to use than a standard overhead projector. Eventually, in the wired classroom of the future, they will be as common as the overhead is in today's classrooms.

If I did not want to use a real-time projection, I could save the image to a file on my computer and then use it later in teaching a lesson. While I was looking at the *David* onscreen, I also found that I could print out a copy of the image on standard 8½" x 11" paper, which I could then photocopy as a handout for students.

Using a news item as a starting point, as in this example, a teacher (or an independent student) might embark on an Internet-based exploration that exemplifies the best characteristics of constructivist teaching and learning. And, because the Internet knows no national boundaries, it is explicitly multicultural. In this example I was able to move easily from websites in the United States to sites in Italy and France. Some

foreign sites require at least a rudimentary knowledge of the host language, but many are available in multiple languages, English invariably being one of them.

## TAKING A VIRTUAL FIELD TRIP

A second example of how to use the Internet as a teaching and learning tool is called the "virtual field trip," the Information Age equivalent of what once was termed "armchair travel." But a virtual field trip involves much more than watching a film travelogue or reading about a faraway place. A number of institutional websites offer online field trips, or virtual tours, of their facilities, ranging from the massive Louvre Museum mentioned above to more intimate collections, such as the Andy Warhol Museum, which is housed in a seven-story converted warehouse in Pittsburgh, Pennsylvania—and online (http://www.warhol.org).

Some tips for developing a virtual field trip are worth mentioning. They do not differ greatly from those with which teachers are familiar with for planning and conducting an actual off-site field trip—except that there are no buses and no box lunches.

*Planning.* Teachers should always "tour" the target website in advance to discover the most accessible pathways to those points of interest they want students to see. Many websites are extensive and complex, so taking an advance tour is indispensable to good planning. The website's site plan can be a valuable tool. Teachers also will find that many websites for museums and galleries contain lesson plans that can make the work of planning how to use the website much easier.

The advance tour also can provide teachers with background information that can be summarized or printed directly from the screen and used to create advance planners and information briefing sheets for their students.

Incidentally, it is wise not to take the advance tour too long before the students' virtual field trip. Otherwise, the website likely will have been changed between viewings. Many websites seem to be in constant flux. "Webmasters" continually add new information, rearrange material, create new graphics and new pathways, and so on. In fact, a website may even be moved to a new web address with little, if any, notice. For example, during the writing of this book, the Louvre

Museum website was completely redesigned and moved from http://www.paris.org/musees/louvre to http://www.louvre.fr

*Before the Field Trip.* Effective teachers recognize that students need to be prepared to take the virtual field trip, just as they are prepared to take a real field trip. This means activating prior knowledge by discussing what the students know about the destination's contents and what they should look for. It will be helpful to develop for or with students a written anticipation ("what-to-look-for") guide.

Small groups of students can take a virtual field trip together, clustered around a single monitor. Groups of students can take different field trips, depending on the goals of the lesson. Or an LCD projector, a large-scale monitor, or multiple linked monitors can be used so that an entire class can take the virtual field trip together.

*During the Field Trip.* This phase is where the virtual field trip has some advantages over the actual field trip. There are no pressures to move the group on and no set speeches by docents. Students can explore subject matter in depth, and teachers can elicit fuller observations, responses to anticipation questions, and so on, in a less hurried fashion. Unlike when a teacher and students take an actual field trip, the virtual field trip also does not have to be limited to a single "visit." In fact, the field trip can be accomplished over several days, integrated with other subjects or activities, or manipulated in other ways to suit the instructional needs of the students.

*After the Field Trip.* Typically, teacher and students debrief following a field trip, and that procedure is no different when taking a virtual field trip—except that it can be done more thoroughly. And students can revisit a virtual field trip destination on their own to review or to explore other content, something that few students are able to do as a follow-up to an actual field trip. Individual, independent tours of previously visited websites and new websites can be encouraged as students gain facility in navigating the Internet on their own. For a complex museum, such as the Louvre, students might later explore the architecture of the building itself, other collections of paintings or sculptures, different individual artists or schools of art, or other artistic periods.

The Louvre, like many museums in non-English-speaking countries, also offers virtual tours in several languages. A virtual field trip to the Louvre, therefore, might also be used as a foreign language activity

with the student taking the virtual tour in French, Spanish, or Japanese. It is an short step from the art of the Louvre to a study of French history and culture, life in Paris, European art, or dozens of other cross-disciplinary topics. A useful compendium in this regard is Cooper and Cooper's *Virtual Field Trips* (1997).

## USING THE INTERNET AS A RESEARCH TOOL

With very little difficulty, even fairly young students can learn how to use the Internet to find information about many art topics. A starting point can be an online encyclopedia, such as *Funk and Wagnalls Online Multimedia Encyclopedia* (http://www.funkandwagnalls.com). More advanced students might go in search of art information in other ways. For example, an interesting research project that could combine history, criticism, and aesthetics might be to locate images of George Washington. How has Washington been portrayed over the past two centuries? By what artists? And where can such images be found?

An excellent starting point for this project is the Smithsonian Institution website (http://www.si.edu). This website provides links to all of the museums and galleries of the Smithsonian, including the National Portrait Gallery, a logical place to look for images of the nation's first President. The link will lead the student to the National Portrait Gallery homepage (http://www.npg.si.edu), which offers a search feature. By typing in "Washington, George," the student will find a list of 76 images of Washington that are part of the National Portrait Gallery collection or a list of 1,013 including images that are housed in other collections.

Each image in the list is described in terms of the sitter(s)—Washington alone or with others in group portraits—the artist, the type of image (painting, sculpture, print, etc.) and medium (oil canvas, mezzotint, concrete relief, etc.), dimensions, date created (if known), current owner, and how the work was acquired. Some of the descriptive listings are illustrated with a thumbnail image of the work. Double-clicking the mouse with the cursor on the thumbnail will call up a larger-size image to view.

The National Portrait Gallery website also allows the researcher to search by artist, type of work, title, or current owner, in addition to—or instead of—the sitter. Thus a student might search just for images of Washington created by Rembrandt Peale and so find works not only in the National Portrait Gallery but also in the Santa Barbara Museum of Art, the Yale University Art Gallery, the Corcoran Art Gallery, the White House, the Crocker Art Museum, the Huntington Library, and many other places—totaling 56 paintings in all. Some, but not all, of these

other institutions also have websites, which may lead to serendipitous explorations. The possibilities are infinite.

<div style="text-align: right">

**REFINING THE MODEL**
</div>

In the previous chapter's final section I suggested that art educators need to think about art education goals and standards, conceptual framework, curriculum, and instruction in two directions, both ends driven and open ended. My initial suggestion, which I have carried through all of these "Refining the Model" sections, is that art education needs to be thought of in terms of *universals, the community,* and *the individual.* In thinking about art education using these categories as organizers, it is important to define what in art is most worth knowing: What are the accepted universals? What art knowledge and understandings are most pertinent to the community? And what should individual learners do and know?

In Chapter 4, I mentioned Wiggins and McTighe's (1998) "backward design," which would be consistent with these ends-driven questions. But to give Grant Wiggins his due, he also has been an outspoken champion of assessment that is better tailored to individual needs and achievements. As Sybil Eakin (1998) comments in a profile piece for *Technos,* "Standards can and should be the basis of the goals of schooling, Wiggins maintains, but they should not be standardized—that is, there should not be a single, narrowly defined standard that all students are expected to meet in the same way at the same time in their careers" (p. 31).

I noted in Chapter 1, in the context of goals and standards, that art educators also must consider the issue of "space," which speaks to a measure of open-endedness. Questions along this line include, how are so-called universals negotiated? By the art world? By nations? By communities? By individuals? What and who constitute a community? Who decides? And, finally, are there limits on the individual? What are they? Who sets them?

This latter point also draws from the best of the creative self-expression movement's philosophy (not to be discarded out of hand) and harkens to educators who talk about how learners construct knowledge and understanding, such as John Dewey (1938), who said, "Perhaps the greatest of all pedagogical fallacies is the notion that a person learns only the particular thing he is studying at the time" (p. 48). Thus in this chapter, for example, I wrote about serendipitous teaching and learning using Internet technology.

Computer technology is a tool, as Grannan and Ganz, the artists I described earlier in this chapter, exemplify. Where such technology is in limited supply, it is a tool simply for enrichment, which I have suggested is the case in most situations for art educators. But as the availability of computer technology increases, the potential also increases for that technology to be transformative. In a 1995 interview, the futurist Chris Dede was asked whether he agreed with some experts' prediction that computer technology would have an enormous impact on K-12 education. He responded,

> It depends on what models of teaching and learning we use. If technology is simply used to automate traditional models of teaching and learning, then it'll have very little impact on schools. If it's used to enable new models of teaching and learning, models that can't be implemented without technology, then I think it'll have a major impact on schools. And if it's used to enable models of teaching and learning that extend beyond the walls of the school into the community, into the workplace, into the family, then it will also have an enormous impact on education and learning. (O'Neil, 1995, pp. 6-7)

Dede averred, in part, that schools have not yet reached the transformative stage because they have used technology merely to do the same old things faster. In this chapter, I have suggested ways that computer technology can be employed to change art-making activities and to enlarge and enhance how teachers and students engage in researching, thinking about, and interacting with art history, art criticism, and aesthetic information and issues. Used in these ways, this new "renaissance" technology becomes one element—over time, a key element—in the critical convergence of ideas that can and should transform how art is taught.

## NOTE

1. Newcomers to the Internet will find it helpful to study one of the many guidebooks available. Two examples are Wishnietsky (1997) and Provenzo (1998).

## REFERENCES

Bailey, J. (1998, Spring). The Leonardo loop: Science returns to art. *Technos*, pp. 17-22.

Cooper, G., & Cooper, G. (1997). *Virtual field trips.* Englewood, CO: Libraries Unlimited.

Dewey, J. (1938). *Experience and education.* New York: Macmillan.

Eakin, S. (1998, Fall). A "lunatic vision" on standards. *Technos,* pp. 30-33.

Evans, C. (1979). *The micro millennium.* New York: Viking.

Ferguson, M. (1980). *The Aquarian conspiracy.* Los Angeles: J. P. Tarcher.

Ingalls, Z. (1999, January 29). Using new technology to create "virtual dance." *Chronicle of Higher Education,* pp. A29-A30.

Janson, H. W. (1962). *History of art.* Englewood Cliffs, NJ: Prentice Hall.

National Center for Education Statistics. (1998, March). *Internet access in public schools* (Issue Brief). Washington, DC: Department of Education, Office of Educational Research and Improvement.

Nolan, M. J., & LeWinter, R. (1998). *Fine art photoshop.* Indianapolis, IN: Hayden.

O'Neil, J. (1995, October). On technology schools: A conversation with Chris Dede. *Educational Leadership,* pp. 6-12.

Provenzo, E. F., Jr. (1998). *The educator's brief guide to the Internet and the World Wide Web.* Larchmont, NY: Eye on Education.

Sypher, W. (1978). *Four stages of Renaissance style.* Gloucester, MA: Peter Smith. (Original work published by Doubleday, 1955)

Wiggins, G., & McTighe, J. (1998). *Understanding by design.* Alexandria, VA: Association for Supervision and Curriculum Development.

Wishnietsky, D. H. (1997). *Internet basics: An educator's guide to traveling the information highway.* Bloomington, IN: Phi Delta Kappa Educational Foundation.

# 6

---

# CRITICAL CONVERGENCE
# AND THE FUTURE OF
# ART EDUCATION

Throughout this book I have used John Godfrey Saxe's poem "The Blind Men and the Elephant" as a metaphor for the critical convergence of ideas that is—or should be—influencing how educators think about art education for the start of a new millennium. Saxe (1816-1887) wrote his famous poem as a moralistic commentary on the theological disputes of his time. The last stanza, the moral, reads,

> So oft in theologic wars,
> The disputants, I ween,
> Rail on in utter ignorance
> Of what each other mean,
> And prate about an Elephant
> Not one of them has seen!

So it is with this critical convergence of ideas, philosophies, and theories in art education. No single element "works" without acknowledging and incorporating the others. It is neither prudent nor sufficient to be a "Standardisto," to use Susan Ohanian's (1998) term for narrow-minded education standards makers, or to be merely a promoter of DBAE or to be just a postmodernist, just a constructivist, or just a computer whiz. One must, if art educators are to realize the promise of rethinking art education, be the best of all of these combined. The promise to be realized by so doing is the repositioning of art at the core of the school experience for all children.

But this repositioning is—and will continue for some time to be—a struggle. "Sad to say," writes Gary Larson (1997) in *American Canvas,* "many American citizens fail to recognize the direct relevance of art to their lives" (p. 13). He goes on to say, "The product of an educational system that at best enshrined the arts as a province of elite cultures and at worst ignored the arts altogether, some people understandably view the arts as belonging to someone else" (p. 13).

In this last chapter, I want to spend some time discussing why and how the arts, writ large, and specifically the visual arts, belong to us—all of us—not "someone else." And, finally, I include an all-too-brief discussion of assessment and research in art education, both of which topics merit a book of their own but must necessarily be given shorter shrift in this work.

## ART EDUCATION AND ACADEMIC ACHIEVEMENT

Elliot Eisner (1998) comments that "we do the arts no service when we try to make their case by touting their contributions to other fields" (p. 15). I disagree in part. I do not diminish the essential concept of art as valuable in and of itself (which I will take up in the next section), but I believe it also is essential to demonstrate from time to time that art education has a reach beyond the studio and the art classroom. Eisner, in a 1998 *Art Education* article, examined the relationship between arts courses (visual arts, music, theater, dance) and academic achievement as discussed in the professional literature over a 10-year period, 1986-1996. Mostly he raised some important questions about the research itself. Cited relationships include

- SAT scores for students who studied the arts for four or more years were 59 points higher on the verbal and 44 points higher on the mathematics portions than students with no such experience (Murfee, 1995).
- The arts make a contribution in such areas as creative thinking; development of cognitive, affective, and psychomotor skills; learning styles, communication skills, literacy skills, and cultural literacy; individual choice-making and group decision-making; and self-esteem ("Building a Case for Art Education," 1991).

But most studies, Eisner contended, are flawed, often, it appears, by the Hawthorne effect.[1] He notes that transference—learning in the arts

transferring an effect to learning in other subjects—is an ambition seldom fully realized. Such transference is simply too general.

> When we talk about the effects of arts education on academic achievement in reading or mathematics, we are expecting transfer of wide scope. To expect that is to expect a great deal. At this moment I can find no good evidence that such transfer occurs. (p. 10)

In this context Eisner seems to disagree with other educators, such as John Brademas (1995), who suggest that a stronger case may be made for "the competencies learned in any art form are in some sense generic and transferable to other subjects" (p. 805). But the disagreement is more semantic than substantive. Indeed, Brademas goes on to suggest that it is a mistake, as Eisner avers, to "champion schooling in the arts on solely utilitarian grounds" (p. 805).

Eisner (1998) makes an important distinction:

> Reports of the effects of arts education on academic achievement appear to be most notable in programs that are specifically designed to help students with reading problems [for example] learn to read *through* the arts. ... These programs are specifically designed to teach reading; the arts are resources to this end. (p. 10)

In this regard Eisner confirms what ought to be a fairly common-sense idea: When art is used as a *tool* in academic learning, it can become instrumental in increasing academic achievement. But, Eisner reasonably contends, it is less likely that art education, absent a direct connection to academic learning, will greatly affect general academic achievement.

Anecdotal evidence of the more specific effects abounds. For example, Beth Olshansky (1995), a laboratory teacher in New Hampshire working with young students, reported that when children's stories are driven by "rich visual images," their writing is "transformed in powerful ways" (p. 47). Roberta Murata (1997), an Albuquerque high school teacher, reported that art making used in her English classes particularly helped visual learners who had trouble decoding words and constructing the continuity of narratives from words alone. And Helen Levin (1998), a teacher in Staten Island, New York, reported positive effects on new adult readers' achievement when freehand drawing was combined with writing, visual memory, and phonics exercises. All of these examples illustrate Eisner's (1998) point that art can be instrumental in raising academic achievement when it is specifically used as a teaching and learning *tool*.

But Eisner (1998) does not dismiss a general effect out of hand. In fact, he posits three ways (or "tiers") that arts teaching contributes to achievement. He calls these outcomes "arts-based," "arts-related," or "ancillary." The first tier relates to arts curricula—that is, curricula within the arts of music, dance, and so forth. The second relates to perception and aesthetic comprehension in the general environment. And the third relates to specific effects, such as enhanced academic achievement, that occur when the arts are used as tools in other disciplines. Eisner reiterates the principles of DBAE theory and the art education standards when he suggests that the "contributions arts education makes to both the arts and to life beyond them" can be identified as four outcomes, the final one being a set of "dispositional outcomes":

1.  Students should acquire a feel for what it means to transform their ideas, images, and feelings into an art form.

2.  Arts education should refine the student's awareness of the aesthetic qualities in art and life.

3.  Arts education should enable students to understand that there is a connection between the content and form that the arts display and the culture and time in which the work was created.

4.  Dispositional outcomes should include (a) a willingness to imagine possibilities that are not now, but which might become; (b) a desire to explore ambiguity, to be willing to forestall premature closure in pursuing resolutions; and (c) the ability to recognize and accept the multiple perspectives and resolutions that work in the arts celebrate. (pp. 12-15)

As much as anything else, it is these "dispositional outcomes" that may lead to the larger purposes of art education.

## AFFECTIVE EDUCATION AND THE CORE CURRICULUM

In the Introduction, I quoted Cawelti and Goldberg's (1997) notion of the importance of the arts. It bears repeating:

The arts are the embodiment of human imagination, the record of human achievement, and the process that distinguishes us as human beings. We form human communities and cultures by making art—through stories

and songs, drama and dance, painting and sculpture, architecture and design. (p. 1)

What Cawelti and Goldberg are talking about is not so much the cognitive aspects of art education as its affective—"civilizing," "humanizing"—aspects. Thus the generalizable effect of art education lies not in enhancing specific academic achievement but, rather, in what Charles Fowler (1994) has called engendering "the languages of civilization" (p. 9).

Fowler (1994) makes the case for art as a core discipline on a broad basis, suggesting that the visual arts offer an essential sensory dimension for constructing new knowledge. He offers an example of describing the Grand Canyon for students. Short of taking students to the Grand Canyon for a firsthand experience, teachers usually resort to describing it with words ("the world's largest gorge . . . a spectacle of multicolored layers of rock carved out over the millenniums by the Colorado River") or numbers ("1 mile deep, 4 to 18 miles wide, and more than 200 miles long"). Words and numbers are simply two symbol systems. Art provides another, essential symbol system for perception, visual symbols conveyed through photographs or paintings, such as Thomas Moran's 1872 painting, *The Grand Canyon of the Yellowstone*. Fowler contends,

> We need every possible way to represent, interpret, and convey our world for a very simple but powerful reason: No one of these ways offers a full picture. . . . A multiplicity of symbol systems are required to provide a more complete picture and a more comprehensive education. (p. 5)

Nor is the contribution of another symbol system solely art's value in the core curriculum. The sensory dimension is valuable as a larger vehicle for creative thinking, which is the case whenever symbols are used to convey alternative perceptions. Words, for example, in poetry, also are a vehicle for creative thinking, which Fowler (1994) contends (as have others) is essential to a complete education.

> Unlike many other subjects students study, the arts usually do not demand one correct response. In this way, the arts break through the true-false, name-this, memorize-that confines of public education. For every problem there may be many correct answers. This kind of reasoning is far more the case in the real world, where there are often many ways to do any one thing well. An effective work force needs both kinds of reasoning, not just the standardized answer. (p. 5)

Education in the arts helps students to disengage from replication and repetition, much the prevailing modes of learning in many disciplines, and to adopt instead—to use Samuel Taylor Coleridge's apt phrase in his *Biographia Literaria* (1817)—"that willing suspension of disbelief for the moment, which constitutes poetic faith" and thereby to allow perception to guide in the construction of new knowledge and understanding. John Brademas (1995) writes,

> Study of and exposure to the arts are unique in deepening the resources of intellect and expanding the horizons of imagination. Creativity, adaptability, sensitivity, discipline, cooperation, risk-taking, critical thinking, self-motivation, the ability to communicate, dedication to excellence—all these competencies are indispensable if the American genius for innovation is to flourish in the economy of the 21st century. As it happens, these are the very competencies that are enhanced by study of and practice in the arts. (p. 804)

Cognitive competencies are enhanced by attention to affective competencies. The most effective teachers have always known this relationship and exploited it. Art education not only contributes an enlarged body of knowledge to the core curriculum, but it also engenders new ways of seeing, new ways of constructing understanding. This new perception fosters creativity that extends beyond the art classroom and positively affects learning in general.

## ART AND CULTURE

The preceding sections touched mainly on the relationship of art education to standards, art disciplines, and constructivist teaching and learning, three perspectives of our elephant of critical convergence. Art education's cultural ramifications reflect the postmodern perspective.

Cawelti and Goldberg's (1997) notion that humans form communities by making art echoes Fowler's (1994) larger idea that "the arts are one of the main ways that humans define who they are":

> Because the arts convey the spirit of the people who created them, they can help young people to acquire inter- and intra-cultural understanding. The arts are not just multicultural, they are transcultural; they invite cross-cultural communication. They teach openness toward those who are different. (pp. 7-8)

This always has been a fundamental purpose of the arts: to challenge narrowness and parochialism of viewpoint, to broaden students' cultural horizons. There are myriad critics of education who would aver otherwise—Ohanian's (1998) "Standardistos" who pursue the setting of education standards mainly for narrow socioeconomic ends, dominant-culture definers who would specify a set culture for all. But in the end there is ample justification for identifying art education as a basic vehicle for making sense of what Elkind (1995) calls postmodernism's "fundamental paradigmatic shift in our abiding world view" (p. 8).

I like the comparison suggested by Joan DeJean (1997) in her discussion of the 19th-century idea of the "fin de siècle" and its applicability to the end of our own century. Fin de siècle (French, literally "end of the century") defined the period at the end of the 19th century that was marked by cultural self-consciousness and despair, not unlike the last of Sypher's (1955/1978) four stages of Renaissance style, the late Baroque period of artistic histrionics leading to "its final crisis of consciousness" (p. 282). In England it was reflected in the cynical extravagance of Oscar Wilde and Aubrey Beardsley. Those "crises" led to artistic renewal. And so, in the face of doomsayers of all sorts at the end of the 20th century—a period complicated by being also the end of the millennium—DeJean asks a pertinent question for our age: "But what if a fin de siècle could also be a positive experience, a time for *cultural renewal?*" (p. 14; italics added).

This point also is embedded in Elkind's (1995) idea that we are experiencing in postmodernism a "paradigmatic shift" from the perspectives of modernism to something else. That something else, as I discussed in Chapter 3, is a culture marked by pluralism and complexity—by definition, multiple cultures clashing, crossing, and coexisting.

Of the French fin de siècle, says DeJean (1997), "It can be argued that the moderns, with their new propositions, were the catalysts for this redefinition of French culture and society" (p. 14). She then suggests that a similar effort must be made (specifically with regard to the university) to turn the endgame despair into positive motivation for transformation. "We must," says DeJean, "quickly channel our creative energy into developing a pedagogy that is more suited to the realities of the new millennium and more responsive to recent attempts to make taste a more inclusive category" (p. 15).

DeJean (1997) could easily be writing about art education, for this is very much the position in which art educators find themselves—that is, in need of developing a new pedagogy, of rethinking how art can and should be taught in the new millennium. This realization, therefore, is yet another discovery, the elephant from yet another vantage point.

## THE TECHNOLOGY PARADIGM

Finally, we come to the last blind man's stanza. Saxe's man of Indostan seizes the elephant's swinging tail and declares the elephant to be "very like a rope." But in the case of art education, it is not a rope at all but a computer power cord.

In Chapter 5, I discussed computer technology in positive terms—which, in the main, is how I view it—but incorporating computer technology into art education cannot be accomplished without some peril. Todd Gitlin (1998), to whose work I referred in Chapter 1, issues an appropriate caution when he comments that today's students "arrive at the university immersed in high-technology media, with only the sketchiest command of history or Western literature, let alone experiences in thinking about similarities and differences among diverse histories and literatures," and, he might have added, "arts" (p. B4). It is easy for students and teachers alike to be overwhelmed by technology and thus to mistake the violin for the concerto. The computer is a tool, a complex set of tools. But it is not the curriculum, nor can educators afford to allow it to become—or to dictate—the curriculum in the arts or elsewhere.

A great deal has been written in the debate over what technoenthusiasts versus technorealists see as the role of technology in education. Technophiles and skeptics can find evidence for every view along the continuum, but the plain fact is that technology is here to stay, it is increasingly present in everyone's life, and it will play an important role in art education. Therefore it is important for art educators to think about the role of computer technology in the teaching of art and how technology can be used productively to increase students' immersion in those "diverse histories and literatures" and arts.

James Bailey (1998) brings the use of technology home to art education with yet another perspective: Art is—must be—a core discipline because new computer technology is effecting a revived linkage between art and science. "Humans and their communications technology," writes Bailey, "form an intellectual team and always have" (p. 18). Before the invention of movable type and the proliferation of books, contends Bailey, art and science were much more interchangeable. He cites Leonardo da Vinci (1452-1519), whom he calls "the last great Western mind before the onslaught of the book," as an example:

It is not just that art and science are interchangeable in Leonardo; so are word and image. He wrote about art; he drew science; and he often did so on he same page of his notebooks. He was at the forefront of two technical

innovations within imagery itself—one in the realm of dimensionality, the other in color. . . . Those who believe that the quattrocento revolutions in viewpoint and dimensionality had no enabling impact on the later science of Kepler and Newton can safely disregard the corresponding revolutions in color and dimensionality happening today. (p. 18)

On the other hand, writes Bailey,

Those who believe that painting the volume of space, known as ether to scientists, between viewpoint and object helped scientists to imagine it as filled with fields of gravitational force will be attentive to the breakdown of the fixed viewpoint that the techniques of virtual reality are bringing about. The advances in artistic dimensionality that are happening today are every bit as significant as those of the Renaissance. (p. 18)

Bailey's point is that the science in virtual reality—whether exemplified in the virtual field trip or virtual dance, both discussed in the preceding chapter—is inextricably linked to art. If, as Bailey claims, "the printing press drove a five-hundred-year wedge between science and art, pushing the latter to the brink of extinction in the curriculum" (p. 17), then it is the new renaissance of technology, the bits and pixels technology of the computer, that is at last reuniting science and art. Art classrooms, avers Bailey, are where the future lies for the high achievers of science and industry in the next century.

## REFINING THE MODEL

I insert this "final" section in midchapter as a way of summing up the foregoing before moving on to discuss a couple of "what next" topics, namely, assessment and research.

In previous "Refining the Model" sections, I dwelled on the necessity of looking at how art is taught from three points of reference: *universals, the community,* and *the individual.* Rethinking art education practice must cross-match these reference points with the perspectives of goals and standards, a conceptual framework, curriculum, instruction, and technology. I identified these perspectives with reference to national goals and national standards and how they might be treated locally (Chapter 1), DBAE theory (Chapter 2), postmodern perspectives for curriculum development (Chapter 3), constructivist teaching practices and undergirding theory (Chapter 4), and computer technology (Chapter 5). With reference to the last perspective, I suggested that

computer use in the art disciplines may now be viewed as "enrichment," but the computer in various forms is rapidly coming to be an essential instructional element in all disciplines, not least in art education.

These starting points for rethinking art education jibe with "best practices" in art education, at least as they have been summarized by Steven Zemelman, Harvey Daniels, and Arthur Hyde (1998). In *Best Practice: New Standards for Teaching and Learning in America's Schools,* they articulate the following "shoulds" for teaching in the arts:

- Students should do art, not just view art.
- The arts should be integrated across the curriculum, as well as taught as separate disciplines.
- Children need to exercise genuine choice, control, and responsibility in their art making.
- Students should be helped to nurture their special talents and to find their strongest art form.
- The arts should be used as a tool of thinking.
- Students should experience a wide variety of art forms.
- Students should have opportunities to share their work.
- Children should attend a variety of professional arts events.
- Artists should be present in schools and classrooms.
- All schoolteachers, not just art specialists, should be artists in their classrooms. (pp. 163-168)

This is a reasonable list for the most part, although I must part company with Zemelman and his colleagues on more basic philosophical matters. If these authors can be faulted, it is for not placing greater emphasis on the other visual art disciplines (art history, art criticism, aesthetics) in addition to art making. These disciplines have been neglected in most art classrooms for the better part of this century. Although students—*all* students—clearly need many opportunities to make art, they also need opportunities to see the contexts, purposes, and uses of art beyond creative self-expression. This goal is embedded in Zemelman and his colleagues' work, but in an inferior position.

Csikszentmihalyi and Schiefele (1992) articulate a position similar to that of Zemelman and his colleagues (1998) but for different reasons:

> In recent years there has been an increased effort to put more emphasis on arts education in our schools . . . at least partially based on the concept of

discipline-based art education. . . . While there are certainly many good points to such initiatives, there is also some danger in such ambitious art programs. The danger is that art education will become more like science and mathematics teaching, and as a result, students will lose their interest in art. (p. 188)

Csikszentmihalyi and Schiefele are concerned about students who are drawn to the arts for precisely the reasons that they are discouraged from pursuing science and mathematics, because these subjects are associated with an "impersonal, instrumental, achievement orientation" (p. 188).

Thus a challenge for art educators in rethinking how art is taught is to solve the dilemma of conceiving art education as an essential, rigorous, core discipline—the knowledge and understandings of which hold broad ramifications for teaching and learning in all disciplines—while simultaneously avoiding the pitfalls of standardization (in curriculum, instruction, assessment, etc.) that can rob art education of its essential affective attributes. This is no small challenge.

A few paragraphs earlier I pointed out the need to cross-match the three points of reference—universals, the community, the individual— with the five perspectives that I have presented as parts of our elephant of critical convergence. This is an enormously complex task, and I hesitate to suggest that it can be reduced to any simple representation. Nonetheless, Chart 6.1 may prove to be a useful starting point as a way of organizing discussion about these important issues.Like the chart in Chapter 2, this one is a simple device, but it may prove to be helpful in clarifying the questions or issues at stake in rethinking art education when addressed using community, school, and individual viewpoints. Framing the concepts in this manner can be especially useful in discussions of art education with non-arts educators, policymakers, administrators, and parents.

## ART EDUCATION AND ASSESSMENT

Assessment is implicit in all of the five component perspectives of the critical convergence. Unfortunately, in an age enamored of standardized tests and testing in general, how educators approach assessment can end up being the driving force in all of them. There are a number of reasons why this should not be allowed to happen.

An appropriate starting point for this brief discussion is goals and standards. In Chapter 1, I recounted Samuel Hope's (1994) notion that

**CHART 6.1**  Organizing the Issues for Discussion

| Universals | The Community | The Individual |
|---|---|---|
| What are the "universals" that must be included in art education? | What are the local (school, community) considerations, such as culture, norms, and expectations, that must be included in art education? | What "space" in art education must be defined in which students can address individual needs, interests, and abilities? |
| Goals and Standards: | Goals and Standards: | Goals and Standards: |
| Conceptual Framework: | Conceptual Framework: | Conceptual Framework: |
| Curriculum: | Curriculum: | Curriculum: |
| Instruction: | Instruction: | Instruction: |
| Technology: | Technology: | Technology: |

national standards for art education should place emphasis on what students should know and be able to do. The national art standards should not prescribe processes, methods, or resources. Rather, they should be generic goals, not lists of specifics or, even less desirable, a national curriculum. There followed, in late 1994, the publication developed by the Consortium of National Arts Education Associations called *National Standards for Arts Education: What Every Young American Should Know and Be Able to Do in the Arts.* The framers of the national standards wisely avoided the pitfall of adhering to the outmoded notion of art mainly as "creative self-expression," a point with which Zemelman and his colleagues (1998) take issue:

The authors [of the national standards] elected to buttress their case by making art sound just like any other school subject, depicting it largely as a fixed body of content that can be transmitted to students in comfortably academic ways. . . . But such factual knowledge only comes alive as it

informs a living, ongoing conversation that students are having, and that is anchored in the constant reality of art making. (p. 160)

Although they argue for balance, Zemelman and his colleagues (1998), in fact, give overwhelming emphasis to art making and offer up praise for the fact that

the arts have been a break for everyone. For kids, they offer an occasional hiatus from the relentless passivity of "real" subjects, a rare invitation to learn by playing, a chance to do something and make something tangible, to have some fun. (pp. 159-160)

I would not argue against the fact that the arts ought to be "fun" or that students ought to have chances to "make something." I would argue, however, that other disciplines might want to lay some claim to these characteristics, too, and that art education need not be dominated by these attributes. Zemelman and his colleagues (1998) take a fundamentally anti-intellectual approach to art education, which is representative of one group of school reformers. Indeed, a key point in the battle to move art back to the core curriculum is necessary recognition that art *is* a "real" subject, that art history, art criticism, and aesthetics are as important as art making—not more important, but *as* important. This is a point that Zemelman and his colleagues neglect, even as they note that "the arts have long led a marginal existence in American schools" and argue for a larger role (p. 158). That they cast that role mainly in terms of art making is unfortunate.

I should point out that I drew in some comments by Csikszentmihalyi and Schiefele (1992) with regard to Zemelman and his colleagues' (1998) position in the last section; I would not want to leave the impression that these writers are parallel thinkers on this latter point, however. Csikszentmihalyi and Schiefele suggest three very different reasons for rethinking how art is regarded in general education, which I will discuss in relation to arts education research in the next section.

The National Art Education Association (NAEA) began its publication, *NAEP Visual Arts Assessment and Exercise Specifications* (1997), with a "This We Believe" statement that says, in part, that the national standards for art "have been framed as deliberately broad statements to enable the development of more specific local curricular objectives" (n.p.). The publication then offers excerpts from *Arts Education Assessment and Exercise Specifications,* prepared by the College Board and approved by the National Assessment Governing Board in 1994. These

assessment examples, however, are highly specific and traditional, emphasizing standard (even standardized) approaches to art making and drawing examples of artworks from the traditional Western canon (Rembrandt, Renoir, Klee, Picasso, etc.). Thus the College Board work tends to reify a "Standardisto" notion that art education, if it is to be regarded as "real" (i.e., "academic," "rigorous") must face the same stultifying standardization as other subjects. This is another camp of school reformers.

Sarah Tambucci (NAEA president, 1995-1997), who wrote the "This We Believe" preface, rightly states, "The *way* art is taught is part of *what* is taught" (NAEA, 1997, p. 1). A counterpart proposition is the oft-repeated notion that what gets tested gets taught. And the way knowledge is tested often also becomes the way it gets taught. Grant Wiggins suggests that assessment should be "frequent, longitudinal, and based largely on authentic tasks and performance" (Eakin, 1998, p. 32). These necessarily are local, individual processes. No national assessment can live up to these requirements. However much the standards makers might want national assessment—including some art educators, who see such assessment as a marker for academic rigor—the real power and potential of assessment lies at the local level, based on locally agreed-on goals and standards. That this assessment also must be rigorous, however "nontraditional," has become a truism—if art education is to move to its legitimate place in the core curriculum. The NAEA's pioneering efforts, although not successful in the broad, national sense, are indicators of possibilities that can and should be pursued in answering local school and classroom questions about art's universals and how communities and individuals can participate in art education.

## ARTS EDUCATION RESEARCH

In 1997 the Goals 2000 Arts Education Partnership published a booklet titled *Priorities for Arts Education Research* (Cawelti & Goldberg, 1997), which offers a starting point for this second brief discussion. The Partnership task force, chaired by Gordon Cawelti and Milton Goldberg, deliberated on the question, "What knowledge can research create that will help schools and policy makers provide an appropriate arts education to American students?" Its response was to recommend 10 areas for further research. These fell into two broad categories: student learning and policy development.

Student learning studies are needed to

- Examine the effects of arts education on (a) the learning and development of children from birth to age 5 and (b) student achievement in the arts and other academic areas
- Examine the effects of arts education on preparing students for successful work and careers
- Examine the effects of arts education on the academic performance of at-risk student populations
- Examine the effects of arts education on student understanding and appreciation of the diversity of cultural traditions in America
- Identify the best instructional practices in the arts along with the most effective methods of professional development for teachers throughout their careers

Policy development studies should involve

- Conducting periodic surveys and data collection that report trends in the status of K-12 arts education in the United States
- Conducting regular surveys to determine the attitudes of the public, policymakers, employers, parents, school administrators, teachers, and students about arts education
- Collecting case studies of state and local school districts where arts education is strongly supported by education policies and practices in order to determine the conditions required for such support
- Studying the effects on arts education of college admission requirements and the hiring criteria set by employers
- Comparing the effects of arts education in American schools to those in other countries in areas of student achievement in the arts, general academic achievement, and other important learning outcomes

Csikszentmihalyi and Schiefele (1992), as I suggested in the previous section, posit some alternative reasons why this type of research (and other forms) should be undertaken. Their reasons harken to the fundamental notion that the "minor role assigned to the arts in society and education needs to be questioned" (p. 169). They suggest three major reasons for rethinking educational and political priorities related to the arts:

1. Technical progress is "as threatening for man's future as it is beneficial"; therefore, "it seems desirable to slow down the development

and production of energy-consuming goods and to direct human creativity" in other ways (p. 169).

2. Automation, decreasing working time, and increasing average age of the population pose problems for the use of free time and "reception as well as production of artistic products . . . should provide people with a valuable alternative to watching TV, to being bored, or to engaging in dull, energy-consuming, or environmentally damaging leisure activities" (pp. 169-170).

3. Arts education holds "value for human evolution and for the development of the individual human being" (p. 170).

It is the third point that Csikszentmihalyi and Schiefele elaborate and with which arts educators most concern themselves, a point that recalls the previous discussion about the unique ability of art education to provide an essential affective component to an otherwise cognitively dominated core curriculum. This affective component also is implicit in many of the research priorities listed by the Goals 2000 Arts Education Partnership (Cawelti & Goldberg, 1997).

Research in art education along the lines suggested, particularly with emphasis on the affective qualities of art education and how those unique, creative, "humanizing" aspects may influence learning in other disciplines, is essential if the theories and philosophies described in this critical convergence are to be realized. John Goodlad (1992), writing in the same volume as Csikszentmihalyi and Schiefele, describes the situation well when he laments

> how difficult it is to buck and then change the tyranny of the existing norms of schooling—standardized testing, state and district regulations, divisions of the school day into subjects and periods—and the regularities seen as right and proper by the community that serve also to provide a sense of security for many teachers. It is hazardous to the health of a school to attempt to go it alone. (pp. 208-209)

Research in art education makes it possible for schools, teachers, and policymakers to garner support so that they do not have to "go it alone."

## A FINAL COMMENT

Painting this elephant of critical convergence in art education has been a messy business. There is paint everywhere. When I get close to the canvas, the image breaks apart, and I am as befuddled as Saxe's blind

men of Indostan. But when I step back, as I urge the reader to do now, it is possible to see the beast for what it is.

Teaching art has always been a messy business. That truth was brought home to me early on. When I was an undergraduate art major at the Kansas State Teachers College (twice rechristened since, now Emporia State University), I remember standing at an easel in a painting class taught by Rex Hall, who was then also the art department chairman. Hall, a veritable dynamo with an enormous salt-and-pepper mustache, was a stylish dresser who rarely appeared in class without a coat and tie. One day he bustled into the studio, took a quick look around at the various canvases being worked on, and spotted a large landscape being painted by a friend of mine. As my friend dabbled with a small brush at his broad expanse of sky, Hall raced up to the easel. "That sky looks like shit!" he announced and grabbed up a three-inch flat brush, stabbed it at my friend's palette, and attacked the canvas. Paint flew everywhere. A dozen broad, vigorous strokes produced not only a perfect sky but also a trail of paint across Hall's natty pants. Oblivious to the mess, he handed the brush to my stunned friend. "That," said Hall, "is how you paint a sky."

And that is how art educators must approach this elephant of converging ideas, theories, and philosophies—not with dabbling, not with feeling this or that part of the elephant, but by stepping to the canvas and boldly addressing the issues. All of the issues. As we urge students to "work the entire canvas" when painting, so too must we concern ourselves with the convergence itself, with the whole canvas of art education, not merely its individual components.

## NOTE

1. When attention paid to individuals increases motivation and increased productivity or achievement results, the outcome is called a Hawthorne effect, meaning that the outcome was achieved through added attention rather than the experimental procedure.

## REFERENCES

Bailey, J. (1998, Spring). The Leonardo loop: Science returns to art. *Technos*, pp. 17-22.

Brademas, J. (1995, June). Valuing ideas and culture. *Phi Delta Kappan, 76,* 804-806.

*Building a case for art education: An annotated bibliography of major research 1990.* (1991). Louisville: Kentucky Alliance for Arts Education.

Cawelti, G., & Goldberg, M. (1997). *Priorities for arts education research.* Washington, DC: Goals 2000 Arts Education Partnership.

Consortium of National Arts Education Associations. (1994). *National standards for arts education: What every young American should know and be able to do in the arts.* Reston, VA: Music Educators National Conference.

Csikszentmihalyi, M., & Schiefele, U. (1992). Arts education, human development, and the quality of experience. In B. Reimer & R. A. Smith (Eds.), *The arts, education, and aesthetic knowing.* Chicago: National Society for the Study of Education/University of Chicago Press.

DeJean, J. (1997, November-December). Culture wars and the next century. *Academe,* pp. 14-15.

Eakin, S. (1998, Fall). A "lunatic vision" on standards. *Technos,* pp. 30-33.

Eisner, E. W. (1998, January). Does experience in the arts boost academic achievement? *Art Education,* pp. 7-15.

Elkind, D. (1995, September). School and family in the postmodern world. *Phi Delta Kappan, 77,* 8-14.

Fowler, C. (1994, November). Strong arts, strong schools. *Educational Leadership,* pp. 4-9.

Gitlin, T. (1998, May 1). The liberal arts in an age of info-glut. *Chronicle of Higher Education,* pp. B4-B5.

Goodlad, J. I. (1992) Toward a place in the curriculum for the arts. In B. Reimer & R. A. Smith (Eds.), *The arts, education, and aesthetic knowing.* Chicago: National Society for the Study of Education/University of Chicago Press.

Hope, S. (1994, March). The standards challenge: A communication from Samuel Hope. *Art Education,* pp. 9-13.

Larson, G. O. (1997). *American canvas.* Washington, DC: National Endowment for the Arts.

Levin, H. (1998, February). A celebration of mind: Drawing improves learning. *School Arts,* p. 26.

Murata, R. (1997, November). Connecting the visual and verbal: English and art for high school sophomores. *English Journal,* pp. 44-48.

Murfee, E. (1995). *Eloquent evidence: Arts at the core of learning.* Washington, DC: President's Committee on the Arts and Humanities.

National Art Education Association. (1997). *NAEP visual arts assessment and exercise specifications.* Reston, VA: Author.

Ohanian, S. (1998). *Standards, plain English, and the ugly duckling: Lessons about the real work of teachers.* Bloomington, IN: Phi Delta Kappa Educational Foundation.

Olshansky, B. (1995, November). Picture this: An arts-based literacy program. *Educational Leadership,* pp. 44-47.

Sypher, W. (1978). *Four stages of Renaissance style.* Gloucester, MA: Peter Smith. (Original work published by Doubleday, 1955)

Zemelman, S., Daniels, H., & Hyde, A. (1998) *Best practice: New standards for teaching and learning in America's schools* (2nd ed.). Portsmouth, NH: Heinemann.

# Suggested Readings

The following publications provide information related to the topics discussed in this book. Some are works cited in the chapters; others offer expanded or related views of the topics addressed in this book.

Cawelti, Gordon, & Goldberg, Milton. (1997). *Priorities for arts education research*. Washington, DC: Goals 2000 Arts Education Partnership.

Consortium of National Arts Education Associations. (1994). *National standards for arts education: What every young American should know and be able to do in the arts*. Reston, VA: Music Educators National Conference.

Cooper, Gail, & Cooper, Garry. (1997). *Virtual field trips*. Englewood, CO: Libraries Unlimited.

Forman, G., & Pulfall, P. B. (1988). *Constructivism in the computer age*. Hillsdale, NJ: Lawrence Erlbaum.

Goldman-Segall, Ricki. (1998). *Points of viewing children's thinking*. Mahwah, NJ: Lawrence Erlbaum.

Greer, W. Dwaine. (1997). *Art as a basic: The reformation in art education*. Bloomington, IN: Phi Delta Kappa Educational Foundation.

Harris, Douglas E., & Carr, Judy F. (1996). *How to use standards in the classroom*. Alexandria, VA: Association for Supervision and Curriculum Development.

Jencks, Charles. (1991). *The language of postmodern architecture* (6th ed.). New York: Rizzoli.

Jennings, John F. (Ed.). (1995). *National issues in education: Goals 2000 and school-to-work*. Bloomington, IN: Phi Delta Kappa International and the Institute for Educational Leadership.

Larson, Gary O. (1997). *American canvas*. Washington, DC: National Endowment for the Arts.

Marzano, Robert J., & Kendall, John S. (1996). *A comprehensive guide to designing standards-based districts, schools, and classrooms*. Aurora, CO: Mid-Continent

Regional Educational Laboratory (McREL). (Copublished with the Association for Supervision and Curriculum Development)

National Art Education Association. (1995, October). *A vision for art education reform.* Reston, VA: Author.

Ohanian, Susan. (1998). *Standards, plain English, and the ugly duckling: Lessons about the real work of teachers.* Bloomington, IN: Phi Delta Kappa Educational Foundation.

Provenzo, Eugene F., Jr. (1998). *The educator's brief guide to the Internet and the World Wide Web.* Larchmont, NY: Eye on Education.

Reimer, Bennett, & Smith, Ralph A. (Eds.). (1992). *The arts, education, and aesthetic knowing.* Chicago: National Society for the Study of Education/University of Chicago Press.

Strong, Michael. (1997). *The habit of thought.* Chapel Hill, NC: New View.

Walling, Donovan R. (1997). *Under construction: The role of the arts and humanities in postmodern schooling.* Bloomington, IN: Phi Delta Kappa Educational Foundation.

Warschauer, Mark. (1999). *Electronic literacies: Language, culture, and power in online education.* Mahwah, NJ: Lawrence Erlbaum.

Wiggins, Grant, & McTighe, Jay. (1998). *Understanding by design.* Alexandria, VA: Association for Supervision and Curriculum Development.

Wilson, Brent. (1997). *The quiet evolution: Changing the face of arts education.* Los Angeles: Getty Education Institute for the Arts.

Wishnietsky, Dan H. (1997). *Internet basics: An educator's guide to traveling the information highway.* Bloomington, IN: Phi Delta Kappa Educational Foundation.

Zemelman, Steven, Daniels, Harvey, & Hyde, Arthur. (1998). *Best practice: New standards for teaching and learning in America's schools* (2nd ed.). Portsmouth, NH: Heinemann.

# Index

CORWIN
PRESS

The Corwin Press logo—a raven striding across an open book—represents the happy union of courage and learning. We are a professional-level publisher of books and journals for K-12 educators, and we are committed to creating and providing resources that embody these qualities. Corwin's motto is "Success for All Learners."